Wisdom With Understanding is Better Than Rubies

Lurine Karon Greenberg
Fine Arts Collection

Designing for Children

ROCKPORT

Designing

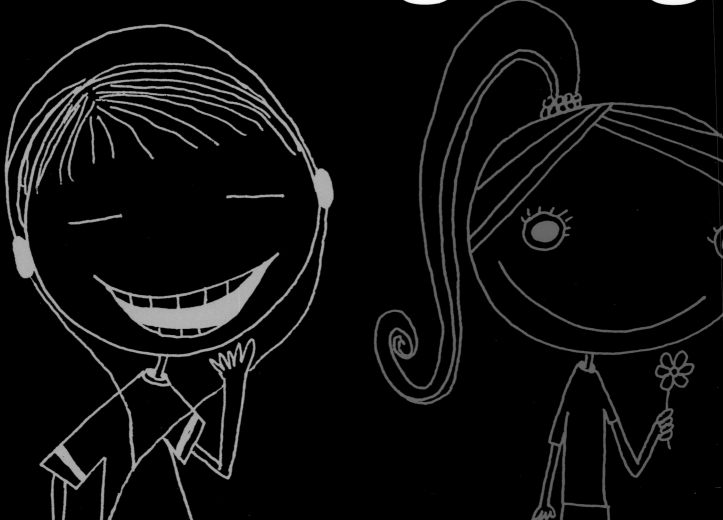

for Children

Marketing Design That Speaks to Kids

Catharine Fishel

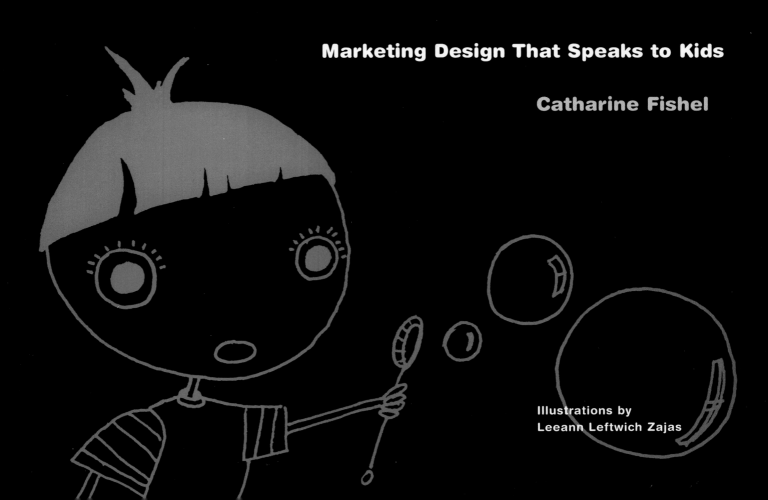

Illustrations by
Leeann Leftwich Zajas

First published in the United States of America by
Rockport Publishers, Inc.
33 Commercial Street
Gloucester, Massachusetts 01930-5089
Telephone: (978) 282-9590
Facsimile: (978) 283-2742
www.rockpub.com

ISBN 1-56496-800-6
10 9 8 7 6 5 4 3 2 1

Design & Illustration: Leeann Leftwich Zajas
Cover Image: Tim Nihoff

Printed in China.

DEDICATION

For Alexander, Andrew, Samuel, Abby, Mitchell, Connor, and Ashley, the seven best reasons I can think of to design well.

Thanks and an A-plus to Julie George for her valuable input to the sidebars in this book; to the students of Jefferson Grade School for their many words of wisdom; to all of the designers and illustrators who generously gave of their time and materials to make this book a success; and to Shawna Mullen and Kristin Ellison for always playing well with authors.

contents

Introduction 10

TOYS **12**
Barbie 14
BRIO 20
Klutz 26
Get Real Girl 32
Crazy Bones 38
Age Cues, Design Clues for 2 to 3 Year Olds **44**

LITERATURE **46**
Nickelodeon Magazine 48
Kid's Discover 54
AIGA Teaching Project 60
Candlewick Press 66
Age Cues, Design Clues for 4 to 5 Year Olds **72**

MEDIA **74**
Zillions 76
Teacher's Pet 82
Noggin 88
Willing-To-Try.com/Funny Garbage 94
Age Cues, Design Clues for 6 to 7 Year Olds **100**

DESTINATIONS **102**
Children's Museums 104
San Diego Zoo and Wild Animal Park 110
Ringling Brothers and Barnum & Bailey Circus 116
Kids' Studio 122
Age Cues, Design Clues for 8 to 9 Year Olds **128**

CONSUMABLES **130**
Cheerios 132
Sonic Wacky Packs 138
Bubble Tape/Amurol Confections 144
Milk Chugs 150
Age Cues, Design Clues for 10 to 12 Year Olds **156**

Directory 158
About the Author 160

Introduction

My nine-year-old's current favorite joke is a perfect illustration of what truly engages a child's imagination. Question: How many surrealists does it take change a lightbulb? Answer: Two—one to hold the giraffe, and another to put the clocks in the bathtub.

"Do you know what a surrealist is?" I asked him, after the 23rd telling, each more hilarious than the last. "No," he said. "Why?"

After I explained the concept behind melting clocks, he thought the joke was even better than before. Now it worked on three levels for him: It meets and greets his appreciation of the absurd; he had the cultural key that unlocked the punch line; and he positively glowed with the satisfaction of knowing he was old enough and had the resources to understand it all.

In other words, the joke delights, informs, and satisfies—exactly the same traits a successful design for a child should possess.

Designing for people with small feet is no small feat. There's something about being a grown-up that makes us forget what it's like to be a child—not that a childhood now decades past has any relevance to the childhood of today. Kids today have lots of consumer savvy and lots of stuff.

The economies involved in producing goods for children can also be intimidating. Today, hundreds of companies do nothing but study or market to children. There are annual awards shows for children's marketing, children's television networks and radio stations, and ad agencies and design firms that are expressly concerned with what is going in inside of those sweet little heads. One publisher interviewed for this book said she receives thousands of queries from hopeful authors and artists each year, each one a heartfelt plea to publish his or her book. Of those, nine or ten get picked up. So anyone serious about this field is playing for keeps.

Then consider the spending dollars at stake. According to one study, in 1999, U.S. children ages 4 to 12 had an amazing $31.7 billion to blow. Another fact: Children 9 to 14 years old get up to $20 per week just for allowance—and about 25 percent of these kids are given additional monies each week unrelated to allowance.

With the economy staying warm for so long, parents and grandparents have been very willing to open their wallets as well.

For the entrepreneurial, there are huge profits to be made. For the altruistic, there are millions of young minds to influence. But to really connect with children, good design is a must. "Marketing" is everywhere, and children can spot its falseness immediately; they know when they are being sold to. The element of good design makes the difference.

Effective design for children does these things:

It delights. It tickles their intellect and causes them to interact with something outside of themselves. This does not mean that a design has to be wacky or humorous; in fact, a clever appeal to a child's intellect often works well. Delighting a child often entails presenting something new—although "new" does not have to mean "never seen before." An innovative toy or book is engaging, but so is a design that puts a new spin on a familiar idea (Pokémon cards sprung from the familiar form of baseball cards, for instance).

It informs. An effective design for a children respects their intelligence. It tells them something about the outside world or about themselves. It is not the same old thing, or, even worse, a copy of the same old thing. Informing children does not necessarily mean "educating" in the traditional sense of providing lots of facts and figures. Informing can also mean helping children develop of sense of fairness, ethics, and just where they fit in the larger world.

It satisfies. Children are just like any other consumer; you might fool them once, but you won't fool them twice. It is possible to attract a child's attention with glitz and promises, but if the product doesn't deliver, that child will never buy your message again. So a good design must satisfy with content, aesthetic pleasure, or value. It has to follow through, and then some.

Great design for children does not do the following:

It is not cute, even if it is colorful and kooky. Children of all ages aspire to be older than they are—marketers call this "age compression." So design that is cute, in children's minds, is design for babies.

It does not pontificate. To the last person, every designer and illustrator interviewed for this book said these words: "Don't talk down to kids."

It does not operate well on preconceptions. That is, a designer should not rely solely on the preferences of his or her own children, nieces and nephews, or the neighbor's kids. Smart communication with children today absolutely requires constant research and attention.

It does not lack red meat. It must have content. It must have substance.

One additional note: Many people believe that designing for children is extremely rewarding and absolutely sloshing with sharing and good-will. In most cases, though, nothing could be farther from the truth. This is a cut-throat field, fraught with lawyers, permissions, and contracts. Onerous copyright and other legal issues lurk around every corner. Witness the production of this book: Three completed articles featuring two extremely noteworthy illustrators and one book publisher had to be discarded at deadline due to the helpful intervention of lawyers.

This is not shared here to discourage potential children's designers. Aside from financial reward, the emotional return on positively influencing a child through design can't be measured. So take the high road and run with scissors, when necessary. Just look out for the bullies.

Catharine Fishel

Author's note: Woven throughout this book are dozens and dozens of quotes from the real authorities—children. Their remarks are insightful, revealing, and, in many cases, touching.

TOYS

Toy land really is boy and girl land. Adults might have their own toys, but they are just borrowing from a world that is not their own. Children are the true connoisseurs.

In this section, we cover five toy brands that are very well-regarded by children:

Barbie: How Parham Santana worked with Mattel to rebrand Barbie and make her even more appealing to moms and daughters.

BRIO: Combining good business and excellent play value and learning experiences.

Get Real Girl: Not exactly the anti-Barbie, but dolls that have made the leap to action figure.

Klutz: Passing on traditions of fun—juggling, cat's cradle, art, bubbles, science—and making them relevant for today's children.

Crazy Bones: A brand and toy that is still taking form, and what the company is doing to get noticed.

Barbie

Parham Santana of New York City has long enjoyed a reputation for handling large, high-visibility projects with professionalism, perception, and aplomb. The firm's recent reimaging of Mattel's Barbie brand, a $1.6 billion product line, is an excellent example. The strategies devised by principals Maruchi Santana, John Parham, art director Maryann Mitkowski, and their creative team affected every product SKU and retail setting for all channels of distribution for the brand, including a 2,500-square-foot Barbie Experience at FAO Schwarz. In this article, they explain how they preserved the heritage of this American icon while making Barbie a more vital brand.

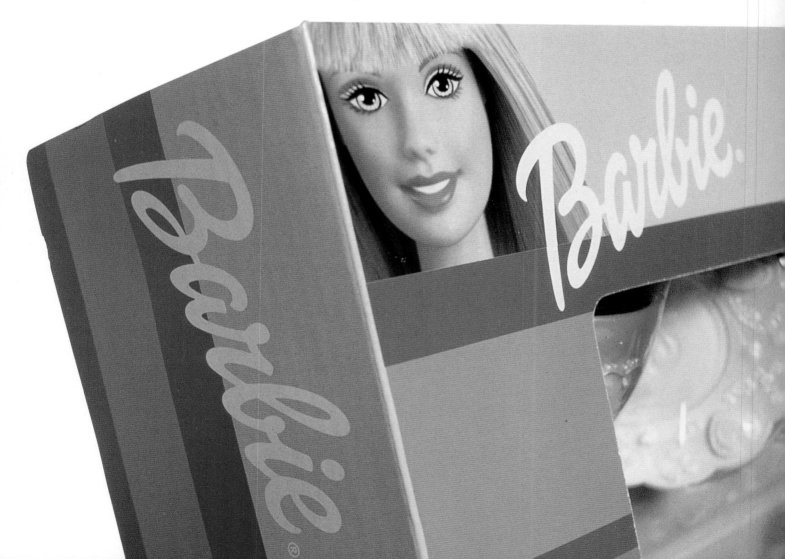

Think Pink

Maruchi: Before we get going, I'd like to thank all of Mattel for collaborating with us and entrusting us with what I think is a great American icon. Having said that, I have to say that I love Barbie. I always used to play with Barbie dolls, and my memory was of how hip she was and how she always kept pace with the times. In working with the new management team at Mattel, we discovered that they also felt Barbie needed to be updated. Freshen it up. Make it for the girl of 2000.

John: Our process is to identify what we call the Most Valuable Positioning—MVP—for a brand. Barbie's MVP was fashion. And while still being fun, fashion meant that she, the brand, had to be contemporary in everything that she does and in all aspects of her appearance.

Maruchi: The branding had to be more like Barbie, the product. You can't say, "This is going to be fun." You can't say, "This is going to be fashionable." It has to be fun. It has to be fashionable.

The brand needed to evolve, and its voice needed to be more accessible. Part of a responsible rebranding effort is to establish rules for the brand voice. In the case of Barbie, she now speaks to girls as friends, as equals, as the smart individuals they are.

John: Barbie might be a marine biologist or an airline pilot, whatever she chooses, but she will be smart and she will look great.

Maruchi: So if this was going to be about keeping up with the times, Barbie couldn't be just pink. In focus groups, moms talked about their love-hate relationship with the color pink. But the girls loved it. Now, the product is for the girls, but we had to talk to the adult with the packaging, our in-store presentation, and so on.

John: Our initial research took us into the various retail environments, and when you look at the Barbie product line, you see just how powerful pink is for the brand. Giving it up would be like asking Coca-Cola to give up its signature red. There had to be a way to keep the overall feeling of the brand without getting overwhelmed by pink.

Maruchi: We developed a color story to support the repositioning, and we introduced a collection of signature brand elements—signature stripes and flowers that became the architecture for all their branding needs. The Barbie signature pink borders the packaging, but the inside is orange or green or pink. We have a complete palette of colors that go with the signature pink and additional colors to highlight and make irresistible the product or outfit that is being presented. The Barbie Fashion Avenue line is a great example of this.

The Barbie brand mark had changed over the years. When we started working with the brand, in fact, a number of variations were being used at the same time. Before we made any changes, we went back to the original Barbie signature mark of 1959, and the characteristics that a signature evokes—real, personal. Script signatures are forever. So we asked, "Why can't we take the original Barbie signature and update it?"

The new Barbie brand identity—essentially, Barbie's signature—is decidedly for the girl of the new decade. Parham Santana also updated the brand's familiar pink with a new palette of bright colors. The look is fresh, but familiar.

"I don't like pink, and I'm a girl. I guess it just depends on the girl you are." Gracie, age 11

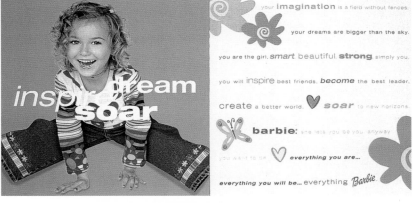

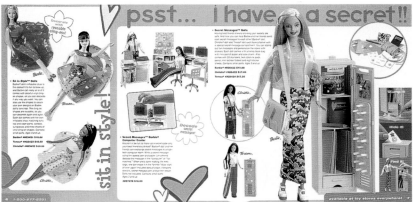

John: The strategy became to preserve the original script for Barbie Collectibles, where it was already being used, and update the signature for everything else. This became a way to preserve the heritage of the brand and evolve it at the same time. Apparently, girls and moms approve, because sales have rebounded.

Maruchi: Together with Mattel, we decided that all of her friends and sisters should have their own signatures. We went to schools and asked kids to write their own names. Sixteen-year-olds were likely to dot their i's with stars or flowers. Younger kids had very round beginner's script. So we found that the style of the signature could visually represent the different age groups for the dolls. Each doll has its own signature.

John: The answer is always there, but you just have to pay attention to it. You have to listen. Understanding the brand and working with kids told us that the Barbie signature should not be a type-face; it should be a real signature. Pink obviously said "Barbie," but the moms said the color needed to be updated. The best design happens when you're informed.

Big and Little Girls

Maruchi: Another thing we created for the moms is a new consumer panel on the box called Barbie Shop Smart. It tells you where to call if you have questions, whether or not the product needs batteries, all helpful information. We know moms are very busy. That information used to be buried in the legal language on the packaging, or was absent all together.

We are treating the girls and the moms like very smart consumers. Now, when they go to the store, the entire product line exhibits a unity and a consistency. So the products are easy to buy, and the presentation is very colorful. It's like eye candy when it is all lined up. Now we are talking to the girls, but talking to the mothers, too.

John: In general, kids are growing up much more quickly today; marketers call it "age compression." The 10-year-old of today is the 15-year-old of yesterday. It's important to make designs for kids more mature, but still fun. Get at the essence of why kids love the brand, but give them a more sophisticated presentation. Some marketers get too kiddy, as if children are from another DNA group. There's a quote we love from Walt Disney:, "You are dead if you only aim for kids. Adults are grown-up kids."

At the FAO Schwarz Barbie Experience, for example, you don't get the impression you are in a toy store. It's more like a boutique. It's much more classic and contemporary.

Maruchi: What I hate with some design for kids is when they are not treated like intelligent human beings. They should be treated right. On the packaging, we introduced Barbie 101, which is a collection of imaginative play ideas, cool tips, awesome stuff that makes being a girl so fun; things like Barbie Glamour 101, Barbie Sport 101, and Barbie Tech 101 were trademarked.

above: Each doll has her own signature, the style of which is based on her age. Parham Santana studied the handwriting of children of different ages and modeled the signatures on those samples.

right: When displayed on the store shelf, Barbie Fashion Avenue packaging and accessory packaging presents an organized but visually exciting effect. Colors are used for identifying as well as differentiating—it's like eye candy, the designers say.

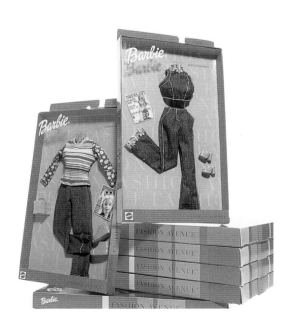

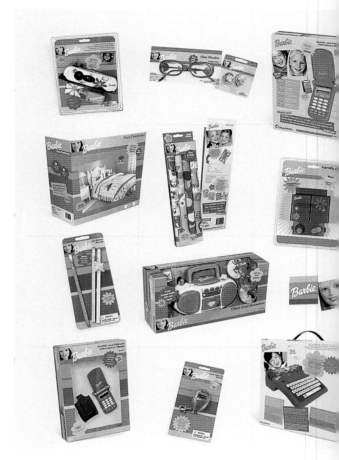

right: Various licensing materials pick up the colors, bars, and signatures that are all part of the new global identity. The New Voice spread and Shop Smart Concept page detail brand-new aspects of the packaging. New Voice blurbs are tips and ideas for fun-loving girls, while Shop Smart is mainly for busy mothers.

Overpromising is another issue. Kids will never want your product again. You can't make it cool through advertising. Products become cool because kids say they are, not because any advertising said it was.

John: With a new or old brand, the important thing is to discover what makes the brand good in the first place, to discover emotionally why a kid would be attracted to it, then define and celebrate this through design. It's one of the reasons for a much more aggressive use of lifestyle photography on the packaging.

Sometimes technology is used to update a toy or make it more attractive. Well, technology can change everything, but it really changes nothing. We all still have the same desires: to have fun, to explore, to pretend. Technology doesn't cause us to evolve. Kids still want to have fun, share, and have relationships. That's human nature in general. And that's what our firm is all about. We're out to brand the feeling.

above and right:
Hangtags and the packaging system for the Barbie Avenue packaging program.

"Pink is a good color for girls because

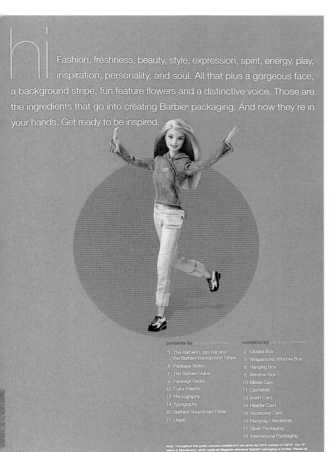

hi Fashion, freshness, beauty, style, expression, spirit, energy, play, inspiration, personality, and soul. All that plus a gorgeous face, a background stripe, fun feature flowers and a distinctive voice. Those are the ingredients that go into creating Barbie® packaging. And now they're in your hands. Get ready to be inspired.

contents by design elements	contents by package format
3 The Barbie® Logo Bar and the Barbie® Background Stripe	2 Closed Box
4 Package Sides	5 Wraparound Window Box
7 The Barbie® Voice	6 Hanging Box
9 Package Backs	8 Window Box
10 Color Palette	10 Blister Card
12 Photography	11 Clamshell
14 Typography	13 Insert Card
20 Barbie ShopSmart Panel	14 Header Card
21 Legal	16 Accessory Card
	16 Hangtag / Necklabel
	17 Silver Packaging
	18 International Packaging

Note: Throughout this guide, process breakdowns are given as CRYK instead of CMYK. The "R" refers to Rhodamine, which replaces magenta whenever Barbie® packaging is printed. Please be

above and left: The 2,500-square-foot Barbie Experience Store at FAO Schwartz rolls out the full Barbie program. The Barbie Girl Boutique (left) and Barbie Doll Accessories and Fashion areas (above) were designed with the girl and mother in mind. But the Barbie Collectible department is for the serious adult Barbie collector.

Parham Santana Team
John Parham / President
Maruchi Santana / Division President, Creative Director
Maryann Mitkowski / Art Director
Kristin Tjandra / Designer
Jessica Gladstone / Designer

Mattel Barbie Team
Adrienne Fontanella / President, Mattel's Girl Product Division
Ivy Ross / Senior Vice President, Worldwide Barbie Products and Visual Design
Cynthia Rapp / Vice President, Worldwide Creative Barbie Licensing
Kelly O'Hearn / Vice President, Girl Packaging Design Group
Mindi Ferronniere / Assistant Product Manager

FAO Schwartz Barbie Experience Store
Parham Santana Team
Maruchi Santana / Division President, Creative Director
Rick Tesoro / Creative Designer
Nina Rossi / Designer

Mattel Barbie Team
Cynthia Rapp / Vice President, Worldwide Creative Barbie Licensing

it looks nice on them." Andrew, age 8

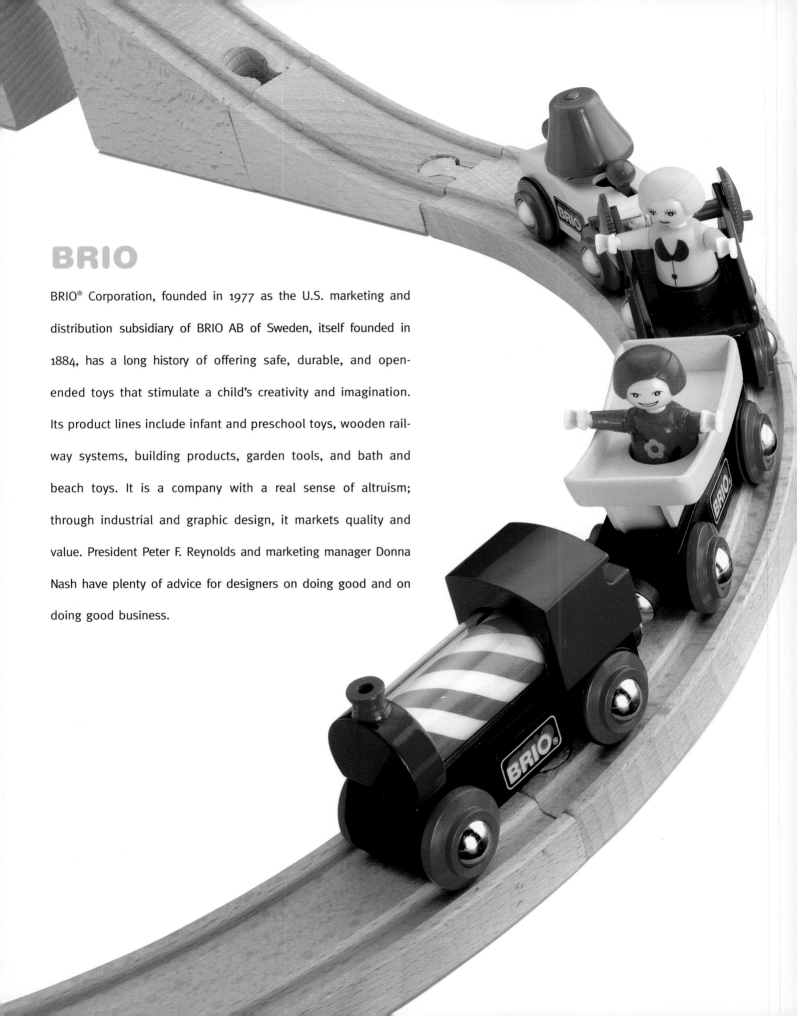

BRIO

BRIO® Corporation, founded in 1977 as the U.S. marketing and distribution subsidiary of BRIO AB of Sweden, itself founded in 1884, has a long history of offering safe, durable, and open-ended toys that stimulate a child's creativity and imagination. Its product lines include infant and preschool toys, wooden railway systems, building products, garden tools, and bath and beach toys. It is a company with a real sense of altruism; through industrial and graphic design, it markets quality and value. President Peter F. Reynolds and marketing manager Donna Nash have plenty of advice for designers on doing good and on doing good business.

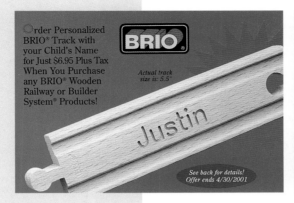
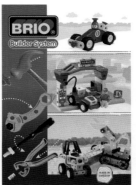

Peter: Altruism and business do not have to operate in different courts. You can put them together, and you can build a marketing plan around the combination. We want to improve children's lives, but there has to be a balance with good business.

The majority of the toy market creates an impetus in the child to want something, but that marketing is usually more sizzle than substance. What we want to do is get people to buy based on value. Playing with a good toy adds to a child's life; playing with a bad toy takes away from his or her life. That's what we want to say.

Donna: In terms of marketing strategy, BRIO is the most philosophical and grass-roots company I've ever worked for. Most toy companies pump out new product every three months with licensing of the latest trend. BRIO works to partner with groups that have the same message that we do. For instance, we work with CIVITAS Initiative [a national, nonprofit communications group that creates tools to help educate and support adults who take care of young children].

Peter: We want not only to be a good toy company but a good information company as well. CIVITAS has simple information and advice on what to do. We can share that information through packaging and products.

Imagine if you had partners like Johnson & Johnson, State Farm, Allstate, and whoever else all trying to provide the best information for children. That has value for all of us; the better the child grows, the better our society will be. I am convinced that a few people carrying a strong, committed message are a lot more powerful than many companies carrying a less focused, watered-down message.

Talk to Whom?

Peter: Mothers do the majority of purchasing of our products. But the products are for their children. They both deserve honest marketing. In the perfect world, every toy package would have the toy name on it and a picture of the product—that's it. Of course, everybody would have to honor those rules, which they wouldn't. I'd give parents the one-minute message from the box, then the five-minute message maybe from the display, then the ten-minute message from the sales staff, and then get them to the Web site. The message is: Play is critical to the development of your children.

Donna: Our consumer focus is definitely parent based, rather than child based. Our packaging is rarely done just for America, but when we focus here, we emphasize the developmental aspect of the toy and what the child is getting out of the product, which also creates the opportunity for greater fun.

For instance, when all the packaging design was done in Sweden, you would see the BRIO name and a photo of a child holding the product on the box. We try to show building skills and other capabilities. The wooden railway pieces come in a green box. The smaller items, like trains, don't have a lot of language on their boxes, but with railway set packaging, we point out all of the pieces in the box, how they can be played with, highlight some of the bigger pieces in the box, and show a photo of the child playing with the set. We emphasize play value. The child instinctively gets it and plays with the toy in a multitude of ways, deriving great enjoyment and fun. The parent has to be shown.

above: The design of BRIO toys and marketing materials is clean. Green is used to identify train products, red is for preschool and infant products, and blue is for builder system products.

opposite: "Add value to children's lives." BRIO's corporate mission dictates that toys and marketing be of the highest quality.

Unconventional Advertising

Peter: We begin with a videotape called *Begin with Love,* developed by CIVITAS, that goes home in the bags that new parents receive from the hospital after their baby is born. The tape includes a lot of information that we have been stressing for the past twenty-five years, backed up with facts, on play value and the importance of connecting with your baby during the first three months of life.

Our next line of getting to the parent is the retailer. We host Good Toy Workshops to help retailers show their customers how important play is and what part BRIO can play in that. We want to help the retailer service the parent to get the child what he needs rather than what he wants. We place display tables in retail settings, too. The parent actually sees the child at the play table and can see the fun, enjoyment, and the value.

Donna: Retailers are our advertisers. You can say only so much on the packaging; too much information just gets overwhelming. The workshops help retailers give parents a blueprint on the benefits of BRIO.

The train tables in stores are a child magnet. That is where mom learns about the train. We also make table donations to museums and doctors' offices. We're working with a children's museum right now to build an actual-size BRIO train. When it's done, we hope other museums will buy the reproductions as well.

Peter: For the parents, we have the *My Railway Adventures.* [This product catalog] contains all of the products, but scattered throughout the design are little words of wisdom that suggest play situations, like, "More than twelve thousand BRIO trains and vehicles are made daily. That's like ordering one thousand large, twelve-slice pizzas." We also show track layouts that the parent and child can build.

left: BRIO marketing is directed toward parents, although its design has a decidedly playful feel. In this spread from the railway wishbook, toys are shown static and in use. Fun facts and quotes from children are tucked in throughout.

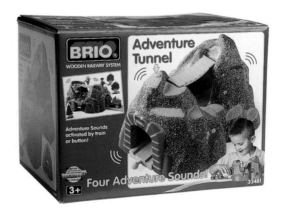

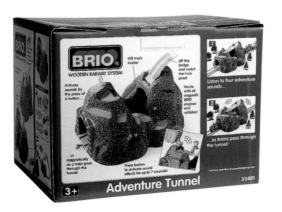

left and below: Children immediately see the fun in BRIO toys, but sometimes parents need a little convincing, so on packaging, BRIO designers include photos of the toy, of the toy in action, and of a child using the toy. Any instructions on use say exactly what the toy does. Overpromising is a recipe for disaster, says marketing manager Donna Nash.

above and below: A new line of BRIO toys, BRIO Friends, is immediately identifiable as part of the company's product line due to the effective use of a similar, but softened, corporate color scheme.

The BRIO Look

Donna: All of our package and product design has a very clean look. We are marketing to adults—grandpa and grandma—more than ever. They have the discretionary income to buy the big sets. But if I were to change the BRIO packaging, I would want to capture the child's imagination more. That has to be done in a way that the child gets out of it what he or she expects. The marketing has to be true to the product.

Peter: There is huge brand equity in our color system. BRIO Wooden Railway owns the color green in the marketplace. BRIO is known for its primary color scheme. With packaging [of other brands] changing all of the time, we want to be the rock in the middle of the stream that everyone can depend on and hold on to. The good thing about BRIO is that it is always the same.

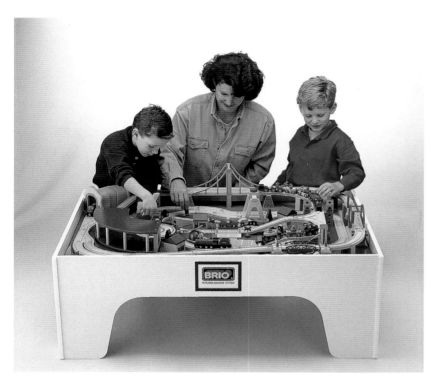

left: BRIO uses its product as advertising, placing play tables into doctor's offices, children's museums, and retail settings. While children play, parents observe—and, perhaps, make a purchase.

below: Designers work to create a store within a store for BRIO's specialty products. Another visual cue for the brand is the clear, blond wood used in many of the company's products.

Take our new BRIO Friends line, for instance. People expect the same BRIO colors. When they see those colors, they know the product is good and that it is good for the child.

Donna: In any design for children, you have to look at the project from a child's perspective. We are so used to looking at things like adults.

Peter: Simple is always better. When you look at some of the more bizarre types of graphics for children, I think those designers are not thinking of children at all. The important thing is to talk to children one to one or to put things into their hands and let them play. I think they are drawn by bright colors. They are drawn to things that are scaled to their size.

I don't even like to call children "kids" in design. It has turned into a marketing thing—the "kids' channel" or the "kids' store." It's like calling an adult by his or her last name rather than their given name. It's disrespectful. I don't think we respect children enough. They are very malleable and easily led. In an environment where bigger is better, we forget how small and precious children are. They deserve design that is honest.

"...I like them because you can look at the instructions and build something complex."
Isaac, age 10

"I think parents do understand what kids like, but only to some extent, considering that kids sometimes don't tell their parents about things that happen." Patrick, age 12

What Grown-Ups Understand About Child Development:

A National Benchmark Survey

Researched by DYG, Inc.

CIVITAS BRIO. ZERO TO THREE

left: An important part of BRIO's corporate identity is as a source for reliable information and advice for working with young children. The company partners with CIVITAS to help educate and support adults who take care of young children with materials like this book for parents, teachers, and caregivers.

Klutz

Klutz had its humble beginnings in 1977, when three Stanford University students began selling sidewalk juggling lessons, complete with a set of three no-bounce beanbags. Today, Klutz publishes how-to-have-fun books on everything from face painting and hair braiding to magic and music. The company's designs still have the feel of a personal lesson from a friend. And even though many deal with "kid" activities, the books are just as popular with adults: Klutz books are fixtures on U.S. book and toy bestseller lists. Art director Mary Ellen Podgorski shares her company's philosophy in designing for children—or not.

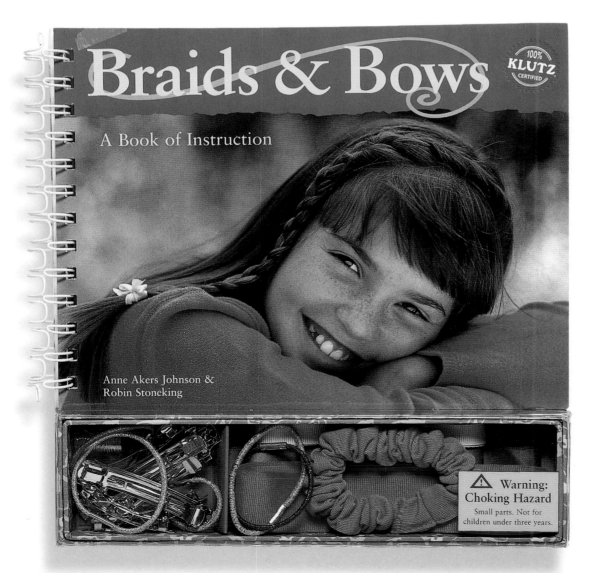

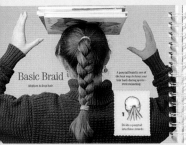
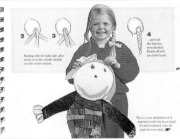
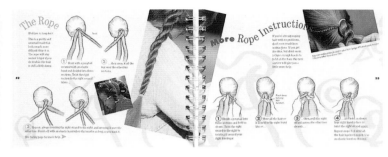

Mary Ellen: Many publishers want their books to look well-designed. Often, our approach is to make it look as though no designer ever came near the page. In fact, the company was in business for ten years before hiring anybody who had ever worked in conventional publishing. We do use grids, although they can be hard to spot. We have no desire to use the same typeface on every page. If we want to treat a page or spread as an individual item, it doesn't bother us if it doesn't look like anything else in the book. We intentionally go for a potpourri look.

In our office, we have a lot of people who think like kids. They are in touch with their immature selves, with short attention spans and such. [Laughing.] So mixing it up keeps things fresh for us and keeps the pace going.

Actually, I never think of designing for kids as different than designing for anyone else. You have to be aware of a child's reading level, but we are not constrained by educational publishing guidelines.

That being said, I have seen designs for children's products that are not well considered or thought out. They show a lack of respect for children as discriminating readers. Kids do love some of the trashiest, grossest stuff, but they also know when they are being fed something recycled or boring. They will say, "This is for babies." It's a matter of being respectful of children as readers and giving as much weight to their opinions as to any adult readership.

When I create a design, I imagine our books on display in a store. The cover should state the title clearly. Once you start flipping through it, the book should be completely browsable and not have anything that makes any one page inaccessible. There might be an attachment on the book, and the toy or supplies inside cannot be skimpy. I want a shopper to see this as a great product in the store, and when they get it home, to feel it is even better than they expected.

An Air of Collaboration

As a designer, you are often handed a project that is already a done deal; you're just supposed to package the editorial. I think we're successful in reaching kids because each book is a collaboration between editorial and design. It is not a case of writing the text and then deciding what art should go with it. The images and text are conceived together. The process is labor intensive and time intensive, but it makes for a tightly woven display of information.

There is also a lot more openness and less restriction about how you can contribute to the project. For example, anyone in the art group can suggest that we rip out a section if it isn't as strong as the others. We all feel free to toss in ideas. Sometimes an idea that starts out really dumb can lead to something brilliant.

We moved into a new office two years ago. It's an old warehouse, so the ceilings are high. There are no cubicles. Every Thursday at 4:00 P.M., we have a company meeting, and everyone attends. We sit on a circle of red bleachers in the middle of the building. We pass around a rubber chicken or alligator, and when it's handed to you, it's your turn to talk. You say how your week is going. Someone in the art group might say, "I'm working on this book and it needs a good title. Does anybody have ideas?" Everyone's answers are valuable.

The office is very lighthearted and fun. The company is very human. On your way from your desk to the kitchen, you can draw on the chalkboard wall, or arrange magnets on the magnet wall, or build something on the Lego wall. You can even bring your pet to work, if it is well-behaved. But we're not goofing off. It all has to do with everyone feeling inspired to make contributions to every book's design and production.

above left: Klutz usually uses real children—not professional models—for the many photos that populate its books. Art director Mary Ellen Podgorski says that this lends a real nature to Klutz books: The children look like the readers, she says.

above right: Klutz designers specialize in making what seems difficult look easy. Through simply worded instructions and, in this case, color-coded pictures, these fancy braids become doable.

opposite: Most Klutz books come with a goodie or two—or a dozen. This book, for example, not only shows kids how to braid and put decorations in their hair, it gives them the rubber bands, ribbons, barrettes, and so forth that they need to complete the projects.

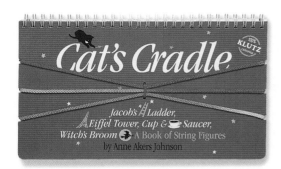

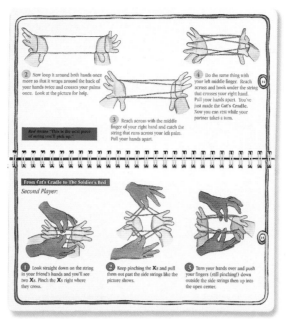

Making It Real

Klutz's real strength is showing how to do something that might have seemed too hard. We want to reassure kids that, yes, you can do this; you will surprise yourself.

To show how to do things, we need lots of art. Technical line drawings are flat, so we use lots of photography in some books to make the processes more real to kids. Especially in younger kids, the leap from looking at a 3-D Lego to a diagram of a Lego on a printed page is huge. As adults, we forget that this is not an automatic translation for them. A photograph or a realistic rendering, though, can help them see what we want them to see.

For process-related topics—say, braiding hair or playing cat's cradle—it can be easy to show someone else how to do it but impossible to describe it verbally. Involved technical art is hard, too: "Cross strand 3 over strands 1 and 2, then cross 2 over 1." It starts to sound like a math equation. For this, we use simplified line drawings with little text: "Cross the right strand over the center, then the left strand over the center." The art can be soft, with watercolor washes and a simple background to make the process the focus. Photos would be too complicated. We try to make the design comfortable for kids— reassuring, friendly, and accessible.

For photos, we rarely work with professional models. Instead, we round up kids from local schools and neighborhoods. They are so much more spontaneous. We have developed long-standing relationships with photographers who are good at making kids relax and just be themselves. When we can get the children to let out that funny side of themselves, it comes across to the reader on the page. The reader knows that he can cut loose, too.

far left: Klutz designers are sometimes able to work the toy component of the game or activity into the design of the book. In this case, a brightly colored string used in *Cat's Cradle* is an integral part of the cover. It can be removed for play and put back when not in use.

left: Again, complex instructions are made simple. Photographs of these same actions would have made the actions too complex and involved; clear drawings are better. Two colors of hands and red accents on various strings also help keep the processes easy to follow.

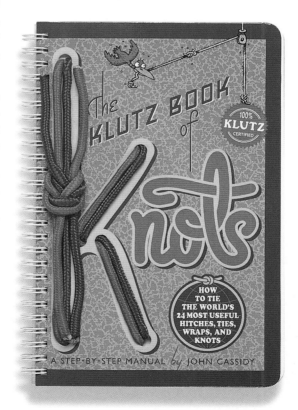

above: For *The Klutz Book of Knots*, the cord supplied to tie knots actually forms the key letter on the cover.

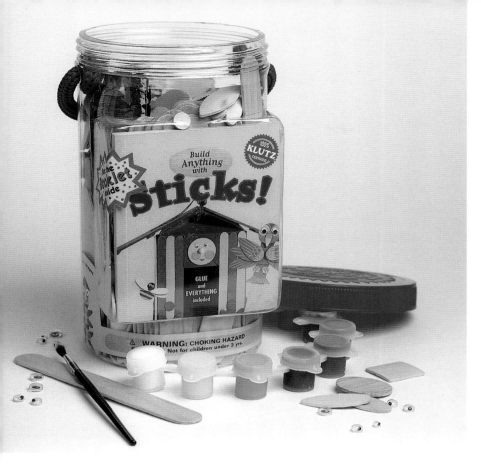

left: Some Klutz books are completely subservient to their containers, like *Sticks!* The tiny instruction book is tucked inside the plastic container with hundreds of wooden cutouts, googly eyes, pipe cleaners, paints, brush, coated wire, and craft glue. Because the child user doesn't have to go searching for a single ingredient, he or she can become involved with the product immediately.

"We have the Klutz big bubble book and wand. It's cool. I can make bubbles as big as me. All the neighbors come to watch." Andrew, age 9

right: Some Klutz books are not books at all. These accordion-folded creations are compact but full of information and fun. Plus, they are laminated for extra durability.

far right: This nail art kit is ingredient-intensive, so it is contained in a standard case—but to make the entire package appealing to kids, the packaging was turned into a prize. The retail card is held to the product by a necklace that matches the product in concept. The lucky little girl recipient gets nail polish, cool ideas, and a necklace.

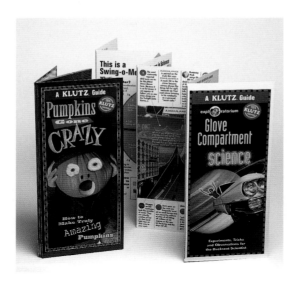

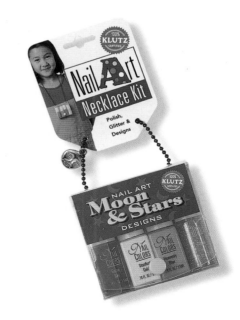

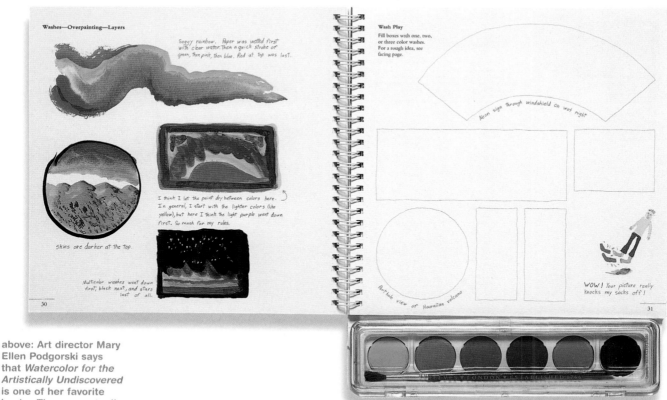

above: Art director Mary Ellen Podgorski says that *Watercolor for the Artistically Undiscovered* is one of her favorite books: The user actually helps illustrate and complete the book.

"I like to make bead ornaments because I can make whatever design I want." Tess, age 11

left and below: Klutz's Web site is a decidedly enjoyable and unusual place. High camp is the order of the day.

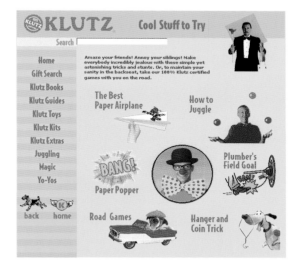

left: Klutz books and guides are displayed so that they can be picked up and paged through easily, especially by children. But Klutz designers are mindful of packing products so they can't become dog-eared or taken apart prior to purchase.

above: What makes the company's Web site so appealing to children is that, in addition to sharing news about all Klutz products, it shows and tells kids how to do awesome things, like juggling and magic tricks.

Testing

We do have a lot of testing venues, although they are informal. Some art teachers let us come to their classes, or we gather a group of moms for a breakfast meeting and show them our ideas. If I am working on a craft book, I may call a Scout leader and ask if her girls would like to try the activities. We also have volunteer kid testers. I tell them, take this home, try it by yourself, then tell me how it went.

All of the Klutz employees are called on for testing, too. We'll find out who knows absolutely nothing about braiding, and that person will be a primary tester of the braiding book.

The design process is all about collaboration and teamwork. Everyone has creative problem-solving abilities. You just have to ask for their input.

Get Real Girl

Get Real Girl™ is not the anti-Barbie, despite how some popular media characterize the new line of action/adventure dolls. Get Real Girl dolls, their packaging, Web site, and accessories are all designed to inspire a healthy, active lifestyle and to empower girls to "get off the sidelines, get in the game"™ (according to its positioning statement). The dolls have toned muscles, realistic body shapes, are completely posable and articulated, and are involved in real-life activities—playing soccer as opposed to being a princess, for instance. Corey™, Claire™, Nakia™, Gabi™, Nini™, and Skylar™, the original team of Get Real Girls, will be joined by Get Real Guys, including Corey's cousin, Jack, and Nakia's twin brother, Piersin, as the brand expands.

Get Real Girl cofounder and former Mattel employee Julz Chavez wished such dolls existed when she was growing up and was inspired to create a doll that truly reflected the lifestyle and attitude of girls of today.

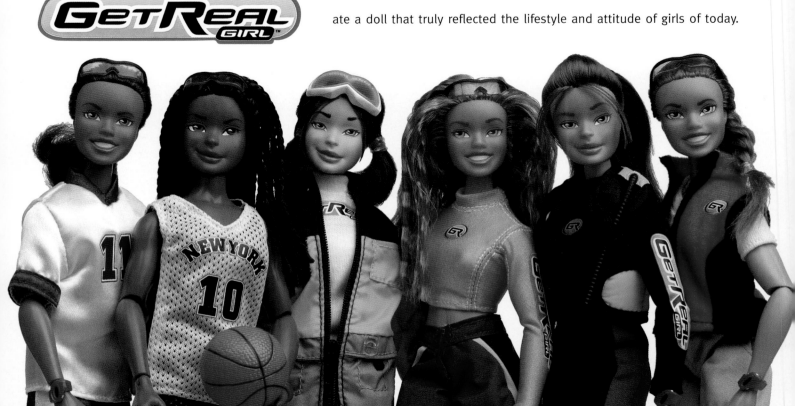

Julz: I worked at Mattel as a senior designer in the preliminary design department in the early 1990s. I knew that Mattel was the largest toy company and had a huge impact on the mass marketing of toys. It was challenging and wonderful up to the point where I realized that I could not listen any more to people telling me that all girls wanted were pink ponies and glittery fashion gowns—in other words, that girls only wanted sweet and soft toys.

As a preliminary designer, I was able to pitch new concepts that I felt reflected the real world of girls of today. I saw how the music industry had a big influence on fashion and attitude and wanted to incorporate that into my concept. More importantly, however, I saw how so many children did not have dolls that represented who they were, and I became focused on creating dolls of all cultures and ethnicities. I began to think that maybe the toy industry was more of a challenge than I had thought, as I met with resistance to my ideas.

It was at this time that I had a conversation with my cousin César [Chavez, the labor leader], and he reiterated the words I often heard from my own father: "You are there to make a difference. You are exactly where you need to be."

My next position, as creative director at Sega Toys, confirmed my belief that technology was making its way into the toy industry. It was quite clear that the next generation of children would be influenced by all media platforms. The questions that I asked at that time were: How is technology addressing girls, and are girls being ignored in this industry?

I knew from past focus groups and testing that girls wanted more realism. They wanted more action. Here again, I could see the influx of the music industry, and I wanted to incorporate that into the gaming technology, too.

My close group of female friends had all played sports at a very early age, and I began to realize what a strong impact that sports had on their lives. Now in their late thirties and middle forties, they are all still active in sports. Today, one out of every three girls plays some sort of sports. I wanted to capture the excitement and adventure of being a girl in today's world.

opposite: Get Real Girls look different from conventional dolls of their size. From asymmetrical faces to fully posable bodies, their design and marketing materials were created to offer children a different kind of play experience.

left: The dolls come complete with story lines and personality. For marketing and packaging shots, they are always photographed outside, in natural settings and with natural light, to heighten their perception as real girls. Skylar is an accomplished snowboarder from Whistler, Canada, with a passion for animal rescue.

No Pink

That was the beginning of Get Real Girl. I met my partner, Michael Cookson, who had a similar philosophy regarding sports and girls. As the founder of Aviva Sports and cofounder of Wild Planet, he would be the best person to align with us to make this happen. Together, we decided to create a doll line that did not talk down to girls. Our stealth name, "No Pink," was Michael's idea, and it was almost the name of our company.

We knew, based on our focus groups, that girls six and older consider Barbie too young for them, so our target group became six years old and up. The Get Real Girl characters were created to be between 16 and 18 years old, so our target audience would look up to the characters and be inspired by them. The Get Real Girls are old enough to have a passport and driver's license and be somewhat independent, but young enough to be curious and not yet know everything.

The packaging design was easy to determine. If you walk down the girls' aisle at the toy store, you see the "great wall of pink." Even products competitive to Barbie are saturated with pink and purple. Our packaging was our only advertising for our first year, so we used it as a commercial in itself. The packaging

above: Nini is a backpacker from Minneapolis who is interested in archeology.

right: Gabi is part Brazilian and lives in San Jose, California. Her dream is to play on the U.S. Olympic soccer team.

far right: Nakia is a basketball enthusiast from Washington, D.C. She hopes to work in television and sports broadcasting someday.

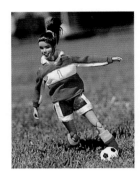

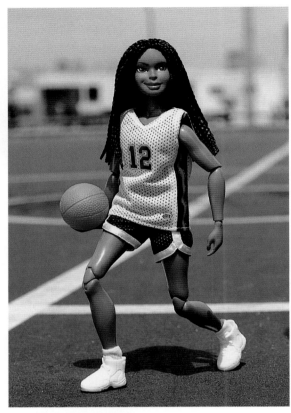

promoted the brand and did not mimic what was already in the market. Our colors, blue and orange, are complementary to the surrounding pink and purple packaging but stand out on the shelf.

Our mission was to make the packaging cool and attractive enough to be sold in a sporting goods store. We had plenty of design agencies coming to us and offering to design the advertising and packaging campaigns for free. But it was important not to go to a toy-packaging design firm. The concern was they have a tendency to repeat the same approaches: clunky graphics and outdated fonts. They simply talk down to kids. This was an opportunity to create something different.

Bringing the Girls On-Line

Our Web site is an integral part of our marketing strategy. GetRealGirl.com encourages girls to play in today's world of technology. The concept was simple: Create a site that resonates with girls. Every character has her own home page, and each page is created as though the character designed it herself. The lifestyle and attitude of each character is reflected in the design.

The aspect of the site that girls love most is being able to e-mail their favorite characters and send postcards to their friends. The "webisodes" are also a hit. Each character's adventure, as told in her personal passport journal, is translated on-line with animated images and educational experiences. We want a child to be able to go on-line and learn more about what a surf safari is, what a loggerhead turtle looks like, and that a joey is a baby kangaroo while navigating through a series of cool photos and moving images.

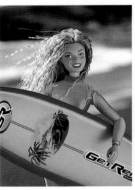

above: Corey is a Hawaiian-born surfer who wants to win the Women's Pro Surfing Tour and someday become a marine biologist.

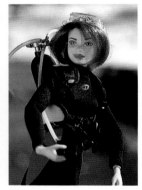

above: Claire dreams of traveling from her hometown of New Orleans to dive in all the oceans of the world, then study medicine and join the Peace Corps.

"Instead of pink,

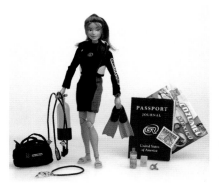
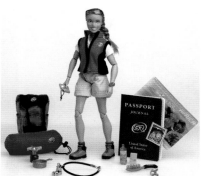

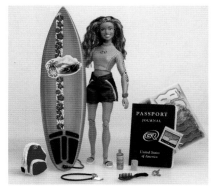
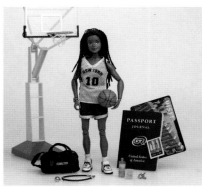
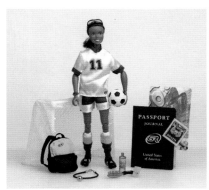
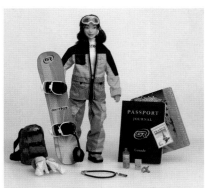

left: The Get Real Girls are all about stories: They have birthdays, hometowns, best friends, pets, favorite pastimes, and even their own e-mail addresses. Their passports share their travels and adventures, while a mix of photos of real girls and of dolls on the boxes blurs the line between a girl's dream and what could really come true.

blue is a good color for girls. It is the color for the sky and the world." D'Anthony, age 7

People ask me why, given our limited resources and no actual national advertising, we don't sell on the Web site. The site was designed as a gift to the girls to extend their play experience. There are no doll sales on the site, although a doll information page details product and store information. There are no banner ads and no chat rooms.

We do use the site as a marketing tool to learn more about what girls want from the product. What sport do they want us to cover next? What Get Real Girl do they want to see next? What is their favorite color? This instant access to our consumers in invaluable. Constant feedback is great. But if a girl does not have a computer, we do not want her to be left behind. All of the Get Real Girl characters come with a passport journal and their own adventure story, so girls can still read about them.

Along with our initial vision of creating a doll property, we had in mind to develop a live-action show with the characters. We would show the girls playing sports, enjoying upbeat music, and just being in action. This is not the usual scene of an adult trying to speak as a child: We want to show what a girl's life is really like.

What's encouraging is that, when we took the characters into the classroom setting for testing, even the boys said, "These are not dolls. They're action figures." They were playing right alongside the girls, getting into the stories of the characters. That's what it's all about—engaging children with a positive, empowering message.

right: This postcard shows the animated and Web site version of the dolls. Get Real Girl developers hope to someday have the characters star in their own action television program.

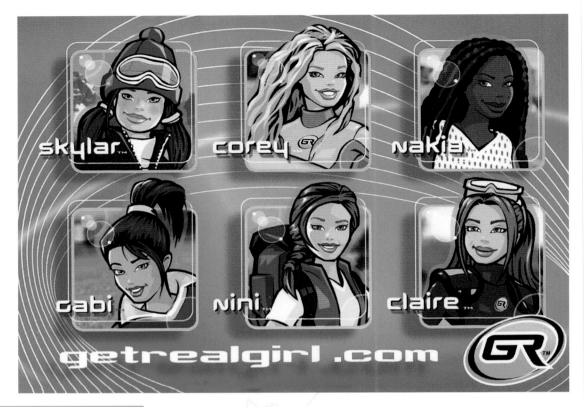

skylar™ corey™ nakia™

gabi™ nini™ claire™

getrealgirl .com GR™

above: The back of the packaging gives the details of the character's life and instructs the buyer where to go for even more information. The bright blue and orange color scheme is complementary with the overwhelmingly pink and purple retail environment in which the action figures are sold.

"My favorite color is purple because it is not dark and it is not light, but it is just right." Kelsey, age 9 1/2

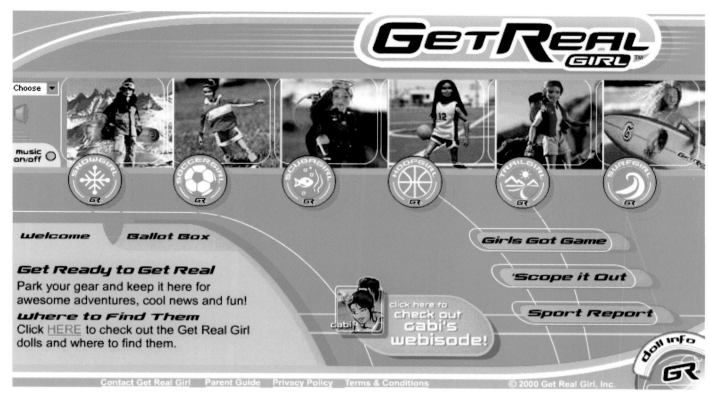

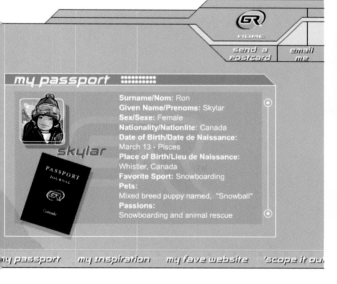

my passport :::::::::::

skylar

PASSPORT
JOURNAL
Canada

Surname/Nom: Ron
Given Name/Prenoms: Skylar
Sex/Sexe: Female
Nationality/Nationlite: Canada
Date of Birth/Date de Naissance:
March 13 · Pisces
Place of Birth/Lieu de Naissance:
Whistler, Canada
Favorite Sport: Snowboarding
Pets:
Mixed breed puppy named, "Snowball"
Passions:
Snowboarding and animal rescue

my passport my inspiration my fave website 'scope it ou

above, left, and below: The Web site extends the play experience for children even further. Not only is there more information in text, some of the characters are alleged to have designed their own pages, so their personality comes through here, too.

to: Cora
from: Kristin

message:

Dear Cora,

Only 6 more weeks till summer!!

See ya!
Kristin

Crazy Bones

Crazy Bones are small, colorful plastic characters that can be used to play any number of games—marbles, dice, jacks, trading, counting, sorting, collecting. Launched only four years ago in the United States by Toy Craze, the little creatures have enjoyed nationwide popularity despite the fact that the parent company spends only 10 percent of its sales on advertising and promotion, compared to the industry standard 20 percent. The trick, says art director Tim Shea, is to meet children in person and get the product into their hands.

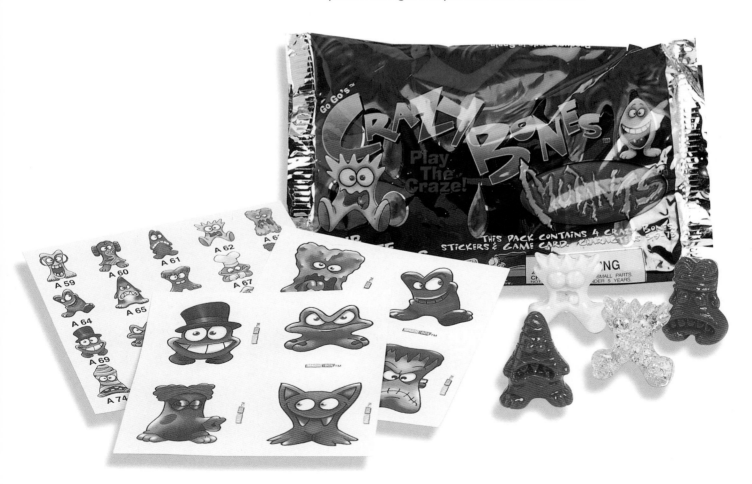

Tim: I think with kids you have to be as creative as possible. Color is really important. Breaking design rules can really work. From what I have learned from this industry, rules are better broken. However, you can't make a design so complicated that a child doesn't know what to do with it. Everything has to be clean and readable. After all, Crazy Bones are an impulse buy. We have only a few seconds to catch a child's attention. We have to get to the point.

I also know that you can't fool kids. If you go cheap on them in the product or the design, they will throw it right out. You shouldn't put too much copy on the packaging. We show the character, some color, and the logo. That's it. Our designs are in your face.

Conventional marketing doesn't work for us. First of all, we don't have millions and millions of dollars for nationally marketing Crazy Bones. So we rely on other methods, like guerilla marketing. The company has four or five purple vans with Crazy Bones characters painted all over them. They make an appearance at a store, host a play day or trading night, and, we hope, the newspapers and TV stations come out and give us coverage.

The "Big Drop"

We also have a quick-start guide that is sent out in what we call a big drop. We have a bag that is created for Sunday newspapers. It holds the paper plus a certificate for a free packet of Crazy Bones. Parents get the paper, see kids playing with the toys, and maybe they go to the Web site for more information. Following the area-wide drop, the demo teams go out in their vans and create an event. Getting the product into the kids' hands—that's the biggest thing.

We have a media bureau that keeps track of all of the news reports from across the country. For instance, we know that forty-five news programs picked up a recent broadcast from a network. That is really valuable knowledge and footage. We use the tapes to make CDs for reps to display to stores and for QuickTime movies on our Web site.

Every time a newspaper mention or broadcast story occurs, it starts little wildfires of sales in those cities. We can't keep the product on the shelves there. But in other cities, sales are stable or lower. I think that's what makes the product a success—we aren't hitting the entire country at one time.

below: The design of Crazy Bones packaging does not have to appeal to grown-ups at all. It's a shiny, colorful impulse purchase that children can afford. Its packaging is very much like candy or baseball card packaging.

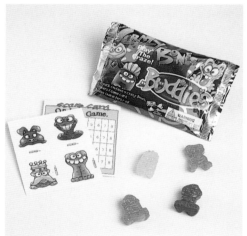

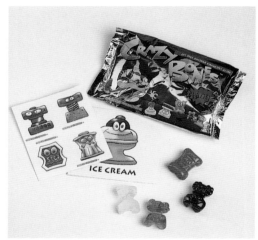

"Lots of times I will buy a toy and ten minutes later the batteries go dead! The batteries cost more than the toy itself! Ha!" Sarah, age 11

CRAZY BONES®
Play
The
Craze!
COLLECTIBLE GAME PIECES

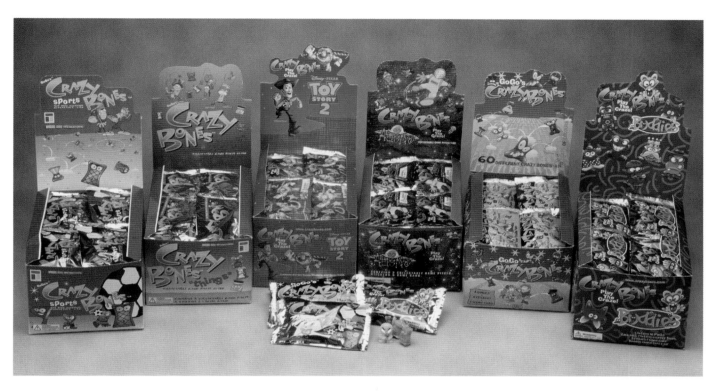

above: In the retail setting, Crazy Bones need to be front and center. Because the product has only seconds to catch a child's attention, its display box is identical to the product packaging, a design with which young shoppers are already familiar.

"The dumbest toy ever invented is a fake compass. What's the point?" Kyle, age 10

A Consistent Identity

Our logo hasn't changed since the product's beginning in 1997. When the third of our ninth series was released, I created a style guide that solidified our look. I will give the logo a different look—say, add a shadow or a glow for a specific product—but, at this stage, there is no need to redo the logo. It's not a logo that most people are familiar with, so it would be easy to change. If we get to the point of doing nationwide advertising, then we would have to think of it.

opposite and right: Everything about Crazy Bones is designed to be collectible, encouraging repeat purchases—the toys' small size, collector cards, stickers, and more.

Sometimes our display boxes are on the front counter of a store, and sometimes they are on the regular store shelves. Some store owners set up displays. We can't control how the boxes are used. So we have to design them to look very cool—but we don't ever say in copy that they are cool. Text is limited, so the logo can easily be seen. And we have been trying to make the copy that details a packet's contents bigger. Parents aren't buying these; kids are, so we design for them.

On the packages themselves, I try to make the characters jump off bags. Using Photoshop, I make the characters and type glow or move to grab the buyer's attention. I also like using bright colors on

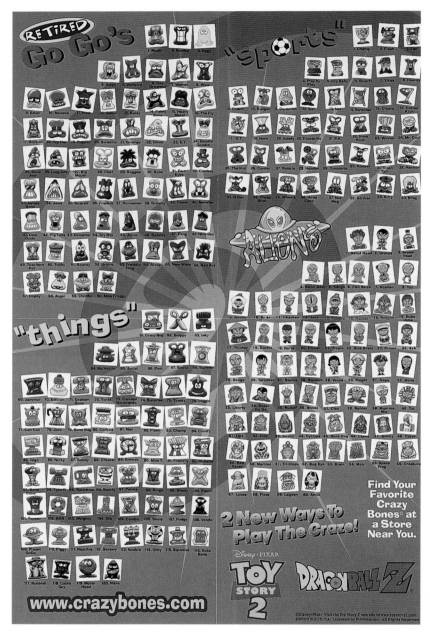

all of the packaging. You can really have fun with Photoshop, and I try to do something different for every project, but you have to know when design becomes too complex and confuses the reader.

The best advice I can offer is that you have to do your homework and find out what kids like. It's hard to be an adult and do this. But you have to get out there and talk to the kids. Our demo teams talk to children every day; then they come back and tell us what they said. It's very exciting.

We never get into traditional focus groups. We just talk to children. Don't even show them your product—just find out what's cool to them right now. Later, you can show them the product. Kids will tell you the truth. If they like it, they will tell you. If they don't, they'll tell you that, too.

"If I could invent the perfect toy, it would be a little plane that could fly and then turn into a boat." Keaton, age 10

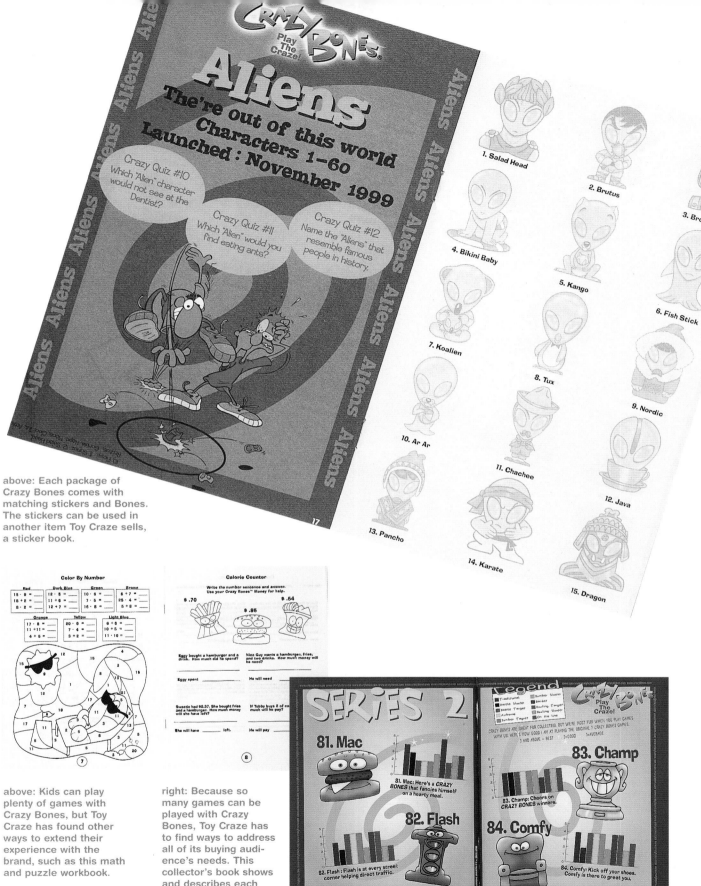

above: Each package of Crazy Bones comes with matching stickers and Bones. The stickers can be used in another item Toy Craze sells, a sticker book.

above: Kids can play plenty of games with Crazy Bones, but Toy Craze has found other ways to extend their experience with the brand, such as this math and puzzle workbook.

right: Because so many games can be played with Crazy Bones, Toy Craze has to find ways to address all of its buying audience's needs. This collector's book shows and describes each character in terms of its aptitude for a host of games.

2&

AGE CUES, DESIGN CLUES

year

Age Cues—Design Clues for 2 to 3 year olds

Just emerging from babyhood, toddlers are sensory creatures. They more than crave new sights, feels, sounds, and smells—they actually need them to develop properly. In other words, they are paying attention—to everything. It's a great opportunity for the designer to introduce more primal experiences.

MOTOR AND PHYSICAL DEVELOPMENT

Motor movements are still unrefined. • Coloring inside the lines or mimicking shapes or actions is difficult. • Designs should encourage child to work out his own ideas.

Cannot concentrate for long periods of time. • Toys and books do not have to start a play experience at the beginning and end at the logical end. • Designs should allow child to add his own contributions easily.

Enjoy exploring, pushing, pulling, filling, dumping, and touching. • Designs should encourage mixing, sifting, pouring, stirring and shaping.

Experience surroundings through touching, smelling, tasting, and feeling.
• Designs should encourages tactile experiences, including sand, mud, clay, and water play.

SOCIAL SKILLS

With two-year-olds, solitary play is common.

Cooperative or parallel play with other children is unlikely. • The child should be able to successfully complete the game or task by himself.

With three-year-olds, parallel play becomes more common; children are influenced by the activities of other children but do not actually play cooperatively.
• Toys and activities should allow more than one child to participate without interfering with others' play.

Cannot sit still or play with the same toy for more than a few minutes.
• Designs should work on a number of levels to maintain interest or improve the flexibility of the play experience. (Example: Blocks can be stacked, sorted by color, built with, and so on.)

Enjoy pretend play; imitate parents. May have an imaginary friend. • Toys that mimic objects from the adult world—play phones, dress-up clothes, and so on— are popular.

Insist on doing things by himself. • Toys and activities should be designed to ensure relative success.

INTELLECTUAL AND COGNITIVE DEVELOPMENT

Enjoy simple stories, rhymes, and songs.

Like to hum and sing. • Simple memorization activities are appropriate.
• Designs that make music or sounds are successful.

Repeat words and names of toys. • Activities that involve knowing the right answer are popular.

Prefer bright colors. • Use bright colors and high contrast.

Can identify body parts when asked. • Designs that emphasize that the child is a unique and separate person are stimulating.

Can use two- to three-word sentences. • Books and activities should use short sentences or single words.

Want to know how to use common items. • Designs can include buttons, zippers, keyboardlike tablets, and so on.

LITERATURE

It's the rare designer or illustrator who doesn't toy with the idea of doing a children's book. This is likely due to the huge number of good examples. This is certainly an area where the crop has plenty of new cream every year. Children's magazines have also proliferated at an amazing rate.

But only the very best designs thrive; the enormous costs behind a publication—paper, printing, and production—kill the rest. Some heavyweight survivors are featured in this section.

Nickelodeon: Wacky, unrestrained, and irreverent, this magazine has become a bellwether that others in the field of children's design watch closely.

Kids Discover: Learning has never been so interesting. The talented staff of Hopkins/Baumann created and continue to nurture this amazingly elegant magazine.

Candlewick Press: Where other children's publishers shoot for syndication, movie rights, and other trappings of the grown-up world, Candlewick is dedicated to producing the best stories with the best design and the very best illustration.

Design Explorers: AIGA National, with the help of dedicated chapter volunteers, launched a remarkable educational initiative aimed at teaching fifth and sixth graders nationwide about design and about themselves.

Nickelodeon MAGAZINE

emerged as a sort of bad boy of the kid's magazine world in 1993—irreverent, media-savvy, and with its finger on the pulse of today's kid. But its enormous success—circulation in the millions around the world—has proven the formula correct. Critics say it is a vehicle for selling Nickelodeon TV shows and products, and even though these entities do make appearances in the magazine, the publication would probably survive just fine without them. That's because its staff has learned to A) keep it fresh, and B) keep it coming. As tempting as it is to ratchet up the altruism when you're dealing with kids, art director Tina Strasberg knows that the magazine needs to be entertainment, pure and simple.

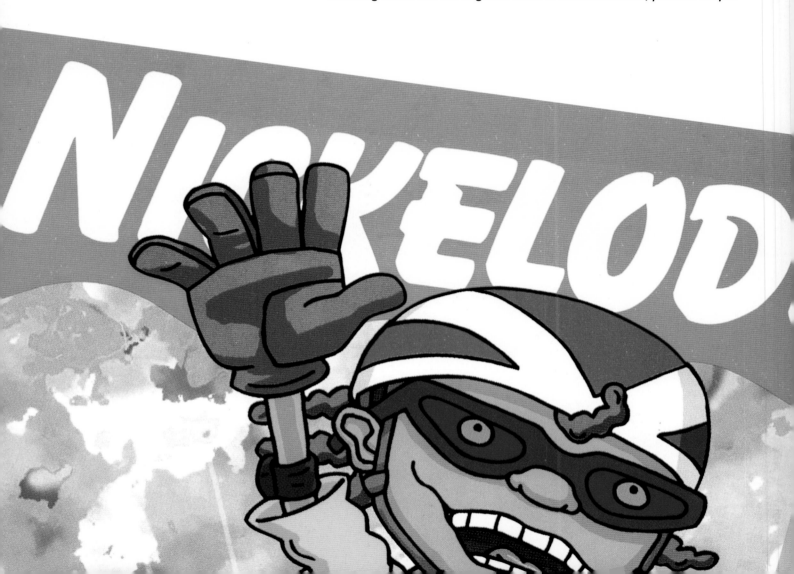

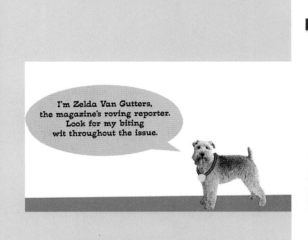

I'm Zelda Van Gutters, the magazine's roving reporter. Look for my biting wit throughout the issue.

Tina: We make various assumptions about what kids like—a lot of it is pure instinct. Lots of kids' products are based on tons of research: What exactly are kids thinking? I think that just fosters unimaginative kids who are supposed to like what all other kids like. We do have a staff of twenty-five kid advisors who tell us what they like about particular issues and what they were most critical of. We also go on school visits to find out what kids are talking about.

It surprises people that not a lot of the staff members have kids. But we are all humor people and childlike and not afraid to say gross stuff like 'snot' because that's the way kids talk. We draw the line at stuff that we don't think is appropriate. For instance, we did this photo shoot where we asked the kids to act up. Some of the kids started punching each other; we would never show something like that. Or if we have a photo of Christina Aguilera with next to nothing on, that won't make it into the magazine. We keep it clean.

My very favorite articles are usually the plays, like "Kneecap Theater." We drew faces on people's kneecaps and took photos of them. There is so much work involved in something like that, but when we pull it off, it's one of the most charming, original things ever. Kids recognize that. You have to look into an assignment and think about what is that unexpected thing that a kid is going to like.

Allowing Spontaneity

We approach the magazine freshly each issue. The theme changes each time, so we can completely change the format each time. The magazine is always evolving. Some themes that we thought would be real duds turn out to be very interesting to kids, like our architecture issue. We just finished an American elections issue that was really strong.

The magazine is very work-intensive. Stories get dropped all the time, and they get redesigned and trimmed back all the time. I fight for large-visual stories. But every designer here is very individual: Each person is obsessive about his or her own likes and dislikes. That means there isn't a traditional flow like you see in other magazines, but the whole thing holds together. There is a familiarity in the way we present things: It's very approachable and immediately engrossing. And up to the very last minute, if there is one little spot of white space, we will try to squeeze in one more little thing that might amuse kids.

opposite and above right: *Nickelodeon* magazine has succeeded by providing young readers with a finely tuned mix of pop culture, real life experiences, and satire. The publication also has a very sophisticated design style that meets the expectations of today's visually experienced readers.

above left: Zelda, Nickelodeon's spokesdog, appears in every issue of the magazine many times, offering her opinions on everything. She's a visual "in-joke" that regular readers know to watch for.

right: The masthead page is "an insane amount of work," says art director Tina Strasberg. But it pulls kids into the magazine right away. "The kids feel as if they are in on the joke. They know us, and they understand it," she says.

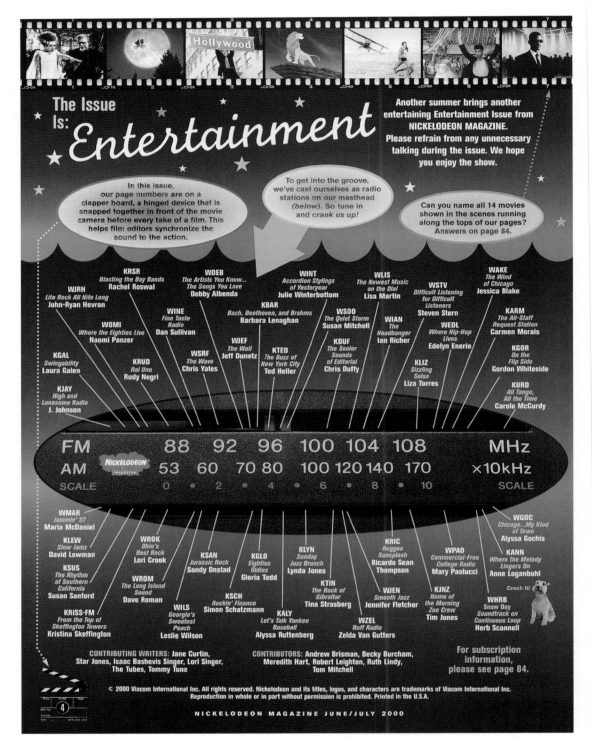

The Issue Is: **Entertainment**

Another summer brings another entertaining Entertainment Issue from NICKELODEON MAGAZINE. Please refrain from any unnecessary talking during the issue. We hope you enjoy the show.

In this issue, our page numbers are on a clapper board, a hinged device that is snapped together in front of the movie camera before every take of a film. This helps film editors synchronize the sound to the action.

To get into the groove, we've cast ourselves as radio stations on our masthead *(below)*. So tune in and *crank* us up!

Can you name all 14 movies shown in the scenes running along the tops of our pages? Answers on page 84.

KRSR *Blasting the Boy Bands* Rachel Roswal

WDEB *The Artists You Know... The Songs You Love* Debby Albenda

WINT *Accordion Stylings of Yesteryear* Julie Winterbottom

WLIS *The Newest Music on the Dial* Lisa Martin

WAKE *The Wind of Chicago* Jessica Blake

WJRH *Lite Rock All Nite Long* John-Ryan Hevron

KBAR *Bach, Beethoven, and Brahms* Barbara Lenaghan

WSOO *The Quiet Storm* Susan Mitchell

WSTV *Difficult Listening for Difficult Listeners* Steven Stern

KARM *The All-Staff Request Station* Carmen Morais

WINE *Fine Taste Radio* Dan Sullivan

WIAN *The Headbanger* Ian Richer

WEDL *Where Hip-Hop Lives* Edelyn Enerio

WOMI *Where the Eighties Live* Naomi Panzer

WJEF *The Wall* Jeff Dunetz

KTED *The Buzz of New York City* Ted Heller

KDUF *The Senior Sounds of Editorial* Chris Duffy

KGOR *On the Flip Side* Gordon Whiteside

KGAL *Swingability* Laura Galen

KRUD *Rai Uno* Rudy Negri

WSRF *The Wave* Chris Yates

KLIZ *Sizzling Salsa* Liza Torres

KJAY *High and Lonesome Radio* J. Johnson

KURD *All Tango, All the Time* Carole McCurdy

FM	88	92	96	100	104	108	**MHz**
AM	53	60	70 80	100	120 140	170	**×10kHz**
SCALE	0	2	4	6	8	10	**SCALE**

NICKELODEON magazine

WMAR *Jammin' 37* Maria McDaniel

WGOC *Chicago...My Kind of Town* Alyssa Gochis

KLEW *Slow Jamz* David Lewman

WROK *Ohio's Best Rock* Lori Crook

KLYN *Sunday Jazz Brunch* Lynda Jones

KRIC *Reggae Sunsplash* Ricardo Sean Thompson

WPAO *Commercial-Free College Radio* Mary Paolucci

KANN *Where the Melody Lingers On* Anne Loganbuhl

KSUS *The Rhythm of Southern California* Susan Sanford

KSAN *Jurassic Rock* Sandy Onstad

KGLO *Eighties Oldies* Gloria Todd

WROM *The Long Island Sound* Dave Roman

KTIN *The Rock of Gibraltar* Tina Strasberg

WJEN *Smooth Jazz* Jennifer Fletcher

KJNZ *Home of the Morning Zoo Crew* Tim Jones

WHRB *Snow Day Soundtrack on Continuous Loop* Herb Scannell

KRISS-FM *From the Top of Skeffington Towers* Kristina Skeffington

KSCH *Rockin' Finance* Simon Schatzmann

WILS *Georgia's Sweetest Peach* Leslie Wilson

KALY *Let's Talk Yankee Baseball* Alyssa Ruttenberg

WZEL *Ruff Radio* Zelda Van Gutters

Crank it!

CONTRIBUTING WRITERS: Jane Curtin, Star Jones, Isaac Bashevis Singer, Lori Singer, The Tubes, Tommy Tune

CONTRIBUTORS: Andrew Brisman, Becky Burcham, Meredith Hart, Robert Leighton, Ruth Lindy, Tom Mitchell

For subscription information, please see page 84.

NICKELODEON MAGAZINE JUNE/JULY 2000

"Adults understand what kids like. They were a kid once. They understand." Haley, age 10

Making them laugh

We try to be entertaining, not judgmental. We are a humor magazine; that's where we end it. It's not a goody-goody magazine—it's irreverent. We are not here to handhold kids. We don't ask kids to send in their most embarrassing moment or anything cheesy like that. It's the humor of the magazine that is so appealing to them: It's sophisticated and doesn't talk down to them.

We did a parody of the Pottery Barn catalog called "Potatoery Barn." I didn't know that you could make a sectional couch and a floor lamp out of three potatoes and make it look really good. An editor with no experience in art decided to make three complete meals out of candy. It turned out great. But originally, the editorial emphasis on the story was to have the kids guess what candy was used to make the food. As the story developed, we decided that the kids would probably rather tear out the pages and hang them on the wall and just think about what the candy is, not write it out.

It's important to not go over kids' heads with humor, though. For instance, we use a fair amount of retro photography, and that may be beyond most kids. Once we were going to put [spokesdog] Zelda into scenes from old holiday movies, but how many kids would really get it? We wonder how many kids are really watching "Survivor"?

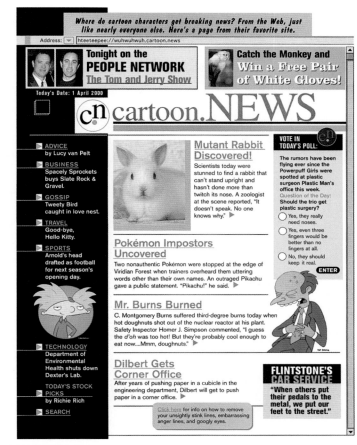

right: The staff often goes to a lot of trouble to pull off a single spread, that's what keeps it so fresh and fun.

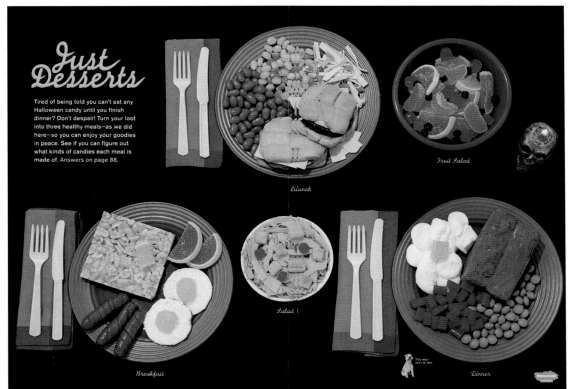

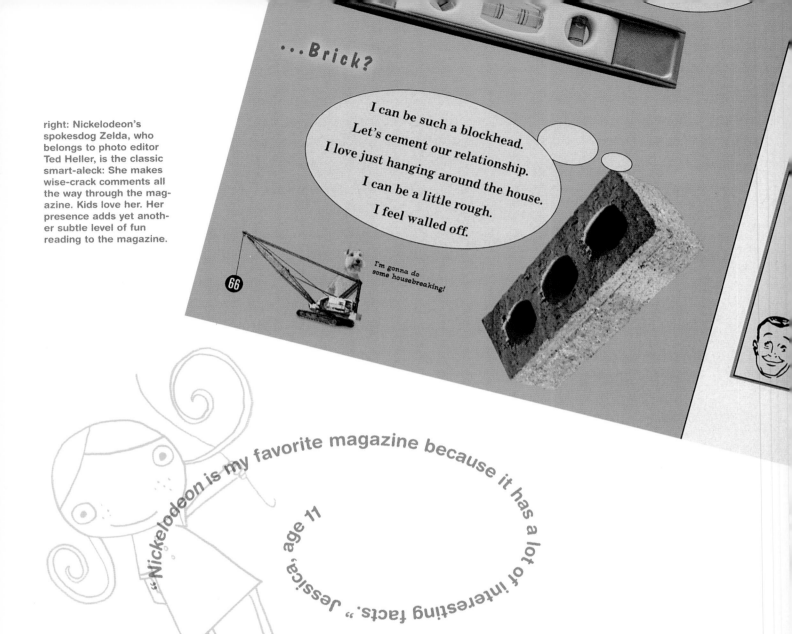

...Brick?

I can be such a blockhead.
Let's cement our relationship.
I love just hanging around the house.
I can be a little rough.
I feel walled off.

I'm gonna do
some housebreaking!

66

right: Nickelodeon's spokesdog Zelda, who belongs to photo editor Ted Heller, is the classic smart-aleck: She makes wise-crack comments all the way through the magazine. Kids love her. Her presence adds yet another subtle level of fun reading to the magazine.

"Nickelodeon is my favorite magazine because it has a lot of interesting facts." Jessica, age 11

Keeping it Light

"Kids really get to feel that they know the staff. They don't understand that this is a real job, just like their parents have real jobs. They think that this is just a fun magazine and we are all hanging out in some fun place and that we're all the same age. They think we're cool, but actually, they know a lot more about stuff than we do. Most of the time we are just winging it. I mean, we don't actually listen to NSync.

"We are just addressing the next big thing, and usually, we make fun of it. You can't seem to be overly earnest. We can't say, 'We think this is cool.' Instead, we just say, 'This is cool.' When you start acting like you know it all, you're preaching. Kids spot that right away."

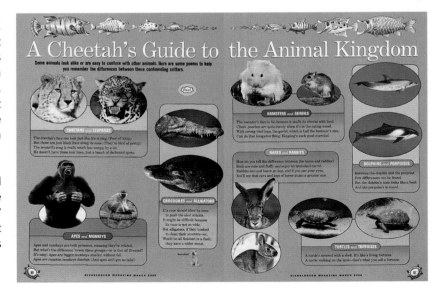

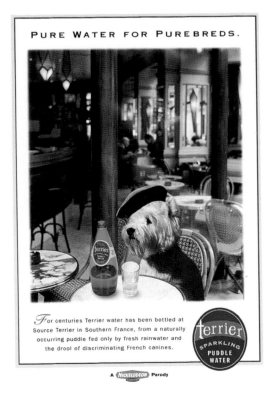

"I believe the ads in magazines." Ashley, age 10

"I don't believe any ads unless they are in the paper." Adrianne, age 10

PURE WATER FOR PUREBREDS.

For centuries Terrier water has been bottled at Source Terrier in Southern France, from a naturally occurring puddle fed only by fresh rainwater and the drool of discriminating French canines.

Terrier SPARKLING PUDDLE WATER

A NICKELODEON Parody

Kids Discover

From its inception in 1991, *Kids Discover* magazine has been a successful anomaly. Many children's publications are stuffed with superlatives and ads, but *Kids Discover* steadfastly presents pure information in each single-subject monthly issue. It is not flashy. It is not campy. It is respectful of children's natural intelligence and of their ability to tackle concepts they might not encounter anywhere else. It has won the Golden Lamp Award for highest achievement in the children's magazine category, as well as two Parents' Choice Gold Awards. Mary K. Baumann and Will Hopkins of Hopkins/Baumann created the original design for *Kids Discover* and, together with editor Stella Sands, cartoonist Michael Kline, infographic designer John Baxter of Acme Design Company, and the illustrators of Wood Ronsaville Harlin, continue to care for it today.

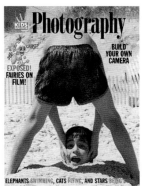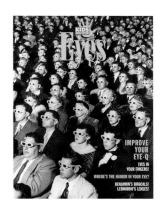

Will: I had worked on a few children's book and magazine projects before this one. I was so turned off by the gatekeepers of children's publications, who lay so many restrictions on you that you can't talk freely with children. The margins have to be a certain size, you have to use serif type, and the type has to be so big. The communication process suffers as a result.

When we got together on *Kids Discover,* we didn't do any of that. In fact, we didn't even focus-group test it. We paid attention to readability and not just the rules. Having said that, I did have a knot in my belly after the first issue was on press. I said to Mary K., "We've broken every rule in the book. I hope we succeed with that." Now we have earned all the major awards for children's publications.

Mary K.: We have established certain operating principles, however. Appeal to children and adults. Don't talk down to kids. Share knowledge. Raise the fun threshold. Communicate visually. Words should take over where the picture leaves off.

The model of *Kids Discover* is the traditional picture story of *Life* and *Look* magazines. Will worked at *Look,* and I worked at Life. In a picture story, each spread is a self-contained part of the story. It has a headline, an intro text block, and pictures linked with captions. We've added to this mix cartoons, infographics, and sidebars.

Will: People don't have to read in a linear manner, starting in the upper left of a spread and moving to the lower right. We're always trying to mess that up by moving things all over the page so the readers have more freedom to explore the spread in their own fashion.

Difficult Ideas, Simple Ways

Mary K.: We all feel that we should not talk down to kids. Adults usually avoid topics that they think might be difficult for children. We don't. We try to explain difficult ideas simply. We think of ourselves as problem solvers for kids. We do it for us, because we're really kids at heart.

We get upset when people don't work with the basic curiosity that kids intuitively have. If we can encourage that curiosity and help kids search for answers, it extends the level of knowledge for everyone. And we can all move forward.

Another thing that often bothers us about design for kids is gratuitous illustration and graphics. We use art only when it provides new information. Like in the Pompeii issue: There was a volcanologist who had taken soil samples from the Mount Vesuvius area. By examining the layers of ash and pumice, he was able to explain the sequence of events on the day the volcano erupted and buried Pompeii. In collaboration with illustrator Rob Wood of Wood Ronsaville Harlin, we were able to explain what physically happened to the people and the terrain as the eruption progressed over time.

For example: "By 5:00 P.M. on August 24, A.D. 79, two or three feet of pumice and ash have accumulated. Thick roofs collapse. Doors can't be opened. People abandon their homes, walking outside with pillows, pots, shields—anything to protect their heads from the heavier falling objects." In the bubbles issue, we compared the strength of spheres, domes, and arches to the strength of the basic bubble shape. We really like to put together connections that are unusual and surprising, so kids look at the world in unconventional ways.

above: "We make the covers as truthfully sensational as possible. We don't really need cover blurbs because we have no newsstand circulation. But the blurbs make it more fun," says Mary K. Baumann.

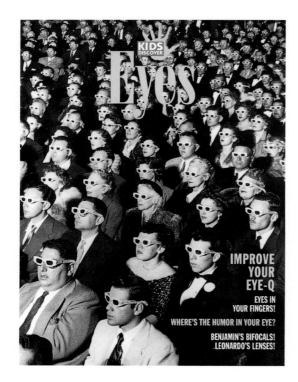

IMPROVE
YOUR
EYE-Q

EYES IN
YOUR FINGERS!

WHERE'S THE HUMOR IN YOUR EYE?

BENJAMIN'S BIFOCALS!
LEONARDO'S LENSES!

"I think kids like to read because you can get lost in a book. Reading helps take stress off of me." Christiaan, age 12

left and below: Although the magazine has been covering components of the body (blood, brain, heart, and bones, to name a few), Will Hopkins says they won't be moving into the birth canal any time soon. "We are read by a lot of home schoolers who are fundamentalist Christians, and they are very sensitive about certain subjects," he says.

The Silliness Quotient

Will: There is something we'd like to improve—our silliness quotient. We need to push ourselves to do that. The issue we did on light comes to mind as a good example. We were working with illustrator Mike Kline in Wichita. We were trying to explain light waves, showing the waves going across a spread, and Mike stuck a surfer on the wave. It was silly, but it worked with kids. It helped us all understand it.

Mary K.: As far as issue topics are concerned, we meet twice a year with owner and publisher Mark Levine, his associate publisher, Bob Elder, and editor Stella Sands. We plan a year ahead. We try to come up with timeless subjects that can work at home and in the school.

Will: On the inside, we try not to be gruesome. At one point in designing the issue on Venice, we had a photograph of a doge's prayer book with a gun hidden inside to illustrate the danger of life in medieval Venice. This issue was coming out shortly after the Columbine shooting, so we took it out. Then there are things like mummies, which are really frightening but funny, too. We think most kids like to be scared a little as long as there's a happy ending. And if you know more about something,

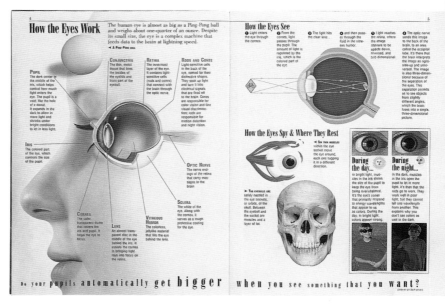

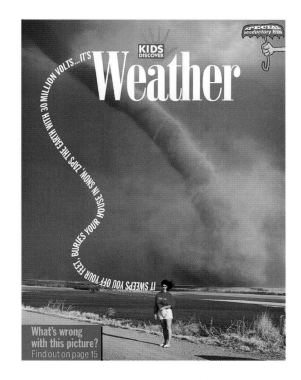

KIDS DISCOVER

Weather

30 MILLION VOLTS...IT'S ... ZAPS THE EARTH WITH ... BURIES YOUR HOUSE IN SNOW, ... IT SWEEPS YOU OFF YOUR FEET

SPECIAL introductory issue

What's wrong with this picture?
Find out on page 15

The Greatest Storms on Earth

Streaks of electricity hotter than the surface of the sun flash across the sky. A tornado picks up a house and drops it hundreds of feet away. A wall of water 25 feet high rushes to shore, pushed by 200 m.p.h. hurricane winds. The surprising thing is, events like these are common. Every year, storms kill and injure thousands of people around the world and cause billions of dollars worth of damage. All we can do in the face of their might is take cover and wait for the storm to pass.

Thunderstorms & Lightning

Tornadoes

WARNING!

WARNING!

you are less likely to be frightened by it. So if we're dealing with something like mummies, we try to make it accessible and funny, not scary.

Mary K.: A lot of people in this world protect kids from anything that is remotely creepy. We think that's dangerous because when you grow up, you are not prepared for how rough life can be.

Will: People have gotten to the point where they are overly careful with almost all types of design. Everything is overly tested. We have been through so many focus groups in our work for other publications: An issue can be selling really well, and the focus group participants will tell you they wouldn't touch it. The best thing that ever happened to *Kids Discover* was that it was never tested. The really successful things are those that people dream about and then go out and do.

"My favorite magazine is Spice Girls because it has music in it." Jessica, age 7

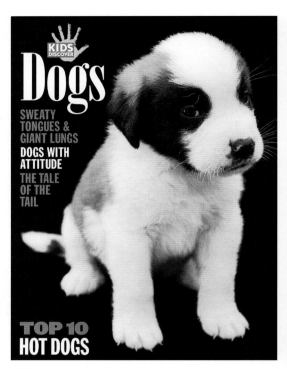

KIDS DISCOVER

Dogs

SWEATY TONGUES & GIANT LUNGS

DOGS WITH ATTITUDE

THE TALE OF THE TAIL

TOP 10 HOT DOGS

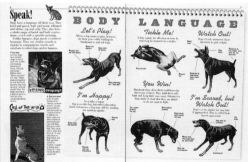

The issues that work best are the ones that shine in both the school and home environment, Mary K. Baumann says. Key to that equation are an editor and writer who are visually oriented.

12

Major Moments

From birth to death, the Incas had customs and practices that influenced every major event in a person's life. Birth, naming, marriage, and even death had their traditional observances.

FEATHER HEADDRESS

SILVER PIN

SHAWL

TUNIC OF COTTON OR ALPACA WOOL

LEATHER

▼ **INCA MOTHERS** wrapped their infants tightly and tied them into these wooden cradles. One leg of the cradle was usually shorter than the other so that the cradle could be rocked. Children were wrapped in the belief that it would help them grow straight.

▼ **INCA CHILDREN** waited a long time to get a name. Until the age of two, they were called by a name that meant "baby." At two, each child got a nickname. Finally, at age 13 or 14, a boy chose a permanent name as part of a coming-of-age ceremony. At that time, he also began wearing a loincloth (a length of cloth around the waist), as a symbol of manhood. At 13 or 14, girls also chose their permanent names as part of a hair-combing ceremony.

named Juanita (right) was found after being buried for 500 years on the summit of Ampato, a volcano in the Peruvian Andes. Buried with her were many artifacts, such as small statues, drinking vessels, and weaving tools. The Incas sacrificed humans at specific times. Calamitous events, such as earthquakes and epidemics, called for sacrificial offerings.

◄ **ARCHAEOLOGICAL** findings give us clues to many aspects of Inca life, like how the Incas dressed and the kinds of things that were buried with them when they died (above). The body of a young girl nick-

"Every dog has his day."
—attributed to Miguel de Cervantes (1547–1616)

1

➤ **FOR THE SON OF A** noble, the coming-of-age ceremony also included tests of bravery and strength and participation in religious rites. The young man had his ears pierced and his first earlobe plugs inserted. Family members gave the boy weapons and other presents. Earlobe plugs, like those below, were a status symbol in Inca society. They were worn only by members of the royal family or the nobility. The larger a man's earlobe plug, the higher his rank in society.

▼ **AFTER COMING OF** age, the sons of nobles traveled to Cuzco, where they spent years learning to become members of the ruling class. They studied Quechua, history, and religion; learned to use the quipu; and received some military training.

▼ **A WOMAN TYPI-**cally married before the age of 20 and a man at 25. The wedding was a no-frills affair. The couple held hands and exchanged sandals.

▼ **WHEN GIRLS WERE** about 10 years old, officials picked the most beautiful and talented to be trained as "chosen women." Some would become the priestesses who assisted in ceremonies at the Temples of the Sun. Other chosen women became wives or servants of high officials.

▼ **AFTER THE AGE OF** 60, the workload for Inca men and women eased. Their labor tax ended and they had easier jobs, such as gathering firewood and baby-sitting.

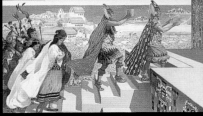

◀ **MANY OBJECTS,** such as this silver llama and this figurine of an Inca doll, were left with the dead at burial pits. The llama may have stood for the herd that the Incas hoped would multiply. The doll may have represented an Inca goddess. Other objects found at burial sites were llama bones, pieces of pottery, and cloth bags holding corn kernels and corncobs.

▼ **THE CLOTHING OF** nobles was distinguished by the design on the cloth and the cloth itself—the finest vicuña wool. This poncho was probably worn by a man of high rank.

▲ **DEAD RULERS** continued to participate actively in royal politics. With the help of assistants, carefully preserved royal mummies ate, drank, visited one another, and sat at councils.

▲ **SCIENTISTS EXAM-**ined Juanita to find out how she lived and how she died.

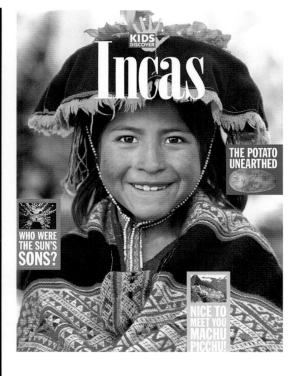

KIDS DISCOVER

Incas

THE POTATO UNEARTHED

WHO WERE THE SUN'S SONS?

NICE TO MEET YOU MACHU PICCHU!

"My favorite kid magazine is *Kids Discover.* It has colorful pictures and interesting facts." Alex, age 11

right: *Kids Discover* designers try to make complex subjects clear, often through illustrations. This explanation of light waves is a good example. "We were showing the waves going across a spread, and artist Mike Kline stuck a surfer on the wave. It was silly, but it worked with kids. It helped us all understand it," says Will Hopkins.

AIGA Teaching Project

In the spring of 2001, AIGA launched an extraordinary, nationwide educational program aimed at fifth and sixth graders. The initiative's goal is not simply to teach children about graphic design but also to help them to become better observers of their world, value and evolve their own ideas, and develop lifelong problem-solving skills. Design Explorers consists of two kits, each containing four design "expeditions": design a journal; invent a building and build a cityscape; create persuasive product packaging; work with patterns by camouflaging a toy frog or butterfly; and four design challenges: design a logo, deck of cards, currency, and a CD cover. In this article, program chair Beth Singer (Beth Singer Design), design director Bill Gardner (Gardner Design), designer Chris Parks (Gardner Design), and logistics director Sam Shelton (KINETIK Communication Graphics) explain how and why the program was constructed.

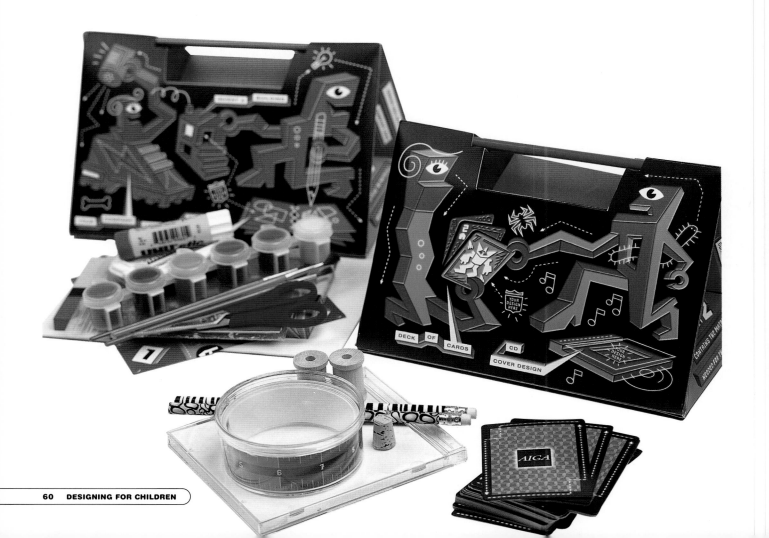

Beth: Design Explorers got its start from ArtStart, a program engineered by Jodi Bloom [of Studio 405]. ArtStart was a one-time program where members of the AIGA-Washington, D.C. chapter went to schools with disadvantaged and at-risk children to enable them to design their own CD covers. It was amazing to see how excited the kids got about the process and how intuitively they took to the design process. I was working with the President's Committee on the Arts and Humanities at the time and started talking to them about a national design project. That got me thinking that perhaps this was something AIGA could do on a national level. The 1990s were good to us as designers. It was time to be giving something back to the community.

What crystallized it for me was being invited to the White House by Hillary Clinton for the Coming Up Taller awards ceremony for arts and humanities programs for children. It was obvious that design was not among the arts programs recognized there. Design is a process that needs to be learned—it's not just an outpouring of creativity. We needed to foster a design program for kids. So the President's Committee got us started and has been guiding us through their experience ever since.

Sam: The great thing about Design Explorer is that, unlike ArtStart, which was a one-shot program, we will have up to eight opportunities to work with the students. Each of the eight projects we created has specific goals. Each is modeled after real-world problems, and each is focused on problem solving. We want the kids to begin to see that everything man-made around them is designed. Design touches everything. As designers, they have a lot of power to make major contributions to their world.

The Job List

Bill: The first project is creating a design idea notebook that will become the road map for designing the rest of the projects. We want the children to build a compendium of ideas that they can use as reference points in any project. The AIGA mentors bring in their own journals as examples. The kids can design the book in any way they want. Some of the materials we provide may speak to them more than others, and they can bring in their own materials, too, things that mean more to them.

Sam: We'd like for students to begin the habit of keeping a visual diary. It's an exercise in self-awareness. Nothing they place in it is judged for aesthetic content, but they are encouraged to collect things they like or feel are well-designed.

Beth: Keeping a journal also leads to better memory skills and utilizing more diverse sources of inspiration in any sort of school or personal work.

Bill: The second project is designing a dream building. It can be a home, a business, a fire station, whatever. Students are encouraged to consider designs that they would like to see, like a grocery store with a slippery slide that sends the groceries right out to your car. They also have to create signage for the building, so the mentors ask them to think about how people respond to different sorts of signs. For example, how come you can identify a McDonald's sign without even reading it?

Once the buildings are all designed, the children have to assemble a community on a long strip of butcher paper. They have to contemplate the placement of all of the buildings. Should the park be next to the houses or the school? Where is the best place for the fire station? This ends up being a threefold experiment: design a building, design signage, and do urban planning.

above: For one project, students are provided a "critter" to camouflage using different colors of paper. They can experiment with patterning and contrast.

opposite: Design Explorers is a nationwide initiative sponsored by AIGA to educate fifth and sixth graders about graphic design and problem solving. Two kits, presented by AIGA mentors, are full of the ingredients children need to design their own logo, currency, product packaging, deck of cards, and more. All that's needed is the imagination of young participants.

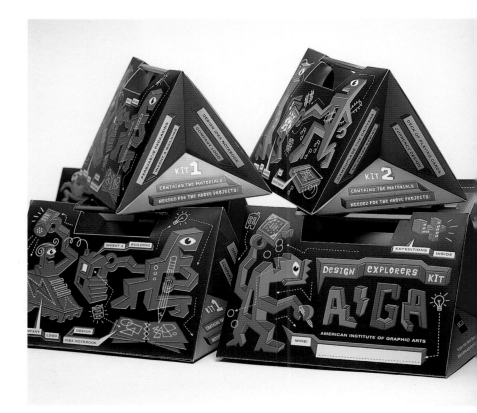

right: Each side of the triangular kit boxes carries graphics with an attitude. Careful study reveals rules being broken everywhere—the dog eating what he's not supposed to have or the natural, 3D world being warped and contorted. The art is meant to encourage young participants in Design Explorers to break conventional design and creativity rules.

Sam: Designing buildings is really outside of the breadth of formal graphic design education, but both the problem-solving exercise and the encouragement to dream about the future of their communities are really worthwhile.

Beth: This is a project that we thought would really appeal to kids. Designing your very own building and seeing how it relates to other buildings in a city touches on real hopes and dreams.

Bill: Next is designing a can or box for a consumer product. Packaging is an easy way to define graphics for children; it helps them visualize exactly what a designer does. We give them a box or can and wraparound sleeves that they can design. But we want them to dream up products that are a little different. Imagine cookies that make you invisible or pet food that turns your pet into whatever you want it to be.

The logo design is the next project. This is a bit more abstract for kids; they may understand that Nike has a logo on the side of their shoes, but they may not understand that Prudential Insurance or Kraft Foods has a logo. So we start at the beginning and talk about things like how the Nike swoosh got its meaning. Why even do a logo? Why not just write your name? The kids are encouraged to develop a logo for their own companies. When the logo is done, the child can put it on a wearable button and place it in a newspaper ad that comes with the kit.

opposite: The first project in Design Explorers is creating an idea journal. Not only do the children create the book—designing its cover, inserting the pages, and binding it—they also fill it with ideas, clippings, colors, and sketches. The ideas collected here are used throughout the expeditions.

"I like to play with crayons the best because I like to enter coloring contests in my spare time." Ashly, age 12

The deck of playing cards was developed in order to have the children examine things like hierarchy and order. We talk about why there are four suits, and why cards and other things are hierarchical. The child is supposed to start his design from scratch, as if no one had ever invented things like spades and hearts. Maybe the child would use tadpoles, small frogs, and big frogs for his face cards—it's completely up to him. This also makes the child deal with developing a theme.

For the currency design project, the kids are made aware that currency holds many clues to culture in addition to being an important trading tool for goods and services. They are first encouraged to develop a theme based on personal interests or values, such as school, family, or hobbies. This theme is then applied to elements such as numbers, seals, legal statements, series, and imagery on the currency. We talk about things like why money is printed with so many protective devices. What can they do to protect their own money?

We want them to design in a way that is unique. We show them currency from other countries so they understand that not all money is green like U.S. dollars. They can do whatever denominations they want.

For the project on camouflaging the critters, we give them brightly colored butterflies and frogs to hide and highlight. The lesson is on making things stand out or blend in. The students work with pattern and contrast. We'll also discuss what real creatures do to make themselves more attractive and how they hide themselves.

Beth: This project has less practical connections than, say, currency or cards, but it does teach them how color, shape, size, and repetition work in conjunction with one another in nature.

Bill: The last project is designing a CD cover for themselves, as if they were the music star. Here, we really make them part of the activity. We bring a commercial photographer into each classroom with props and costumes to take photos of the kids for the designs. They have to think about not only how to design such a thing, but also what their music would be like.

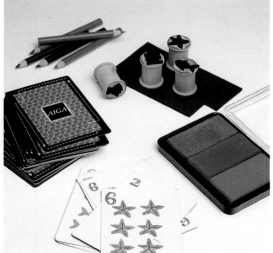

left: When they design a set of playing cards, students must consider concepts such as hierarchy, order, and carrying a visual theme. The kits contain materials for building a rubber stamp that allows young designers to create and then stamp their own suits.

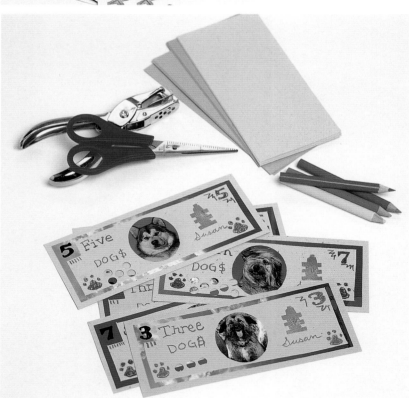

"I would rather do art than read or play a sport. I am a good drawer." Jared, age 9

above: Designing currency exposes children to visual consistency and repetition and to confronting the regular order of the world. Does money have to be green? rectangular? in $1, $5, and $10 denominations? Students are encouraged to reconsider every aspect of money.

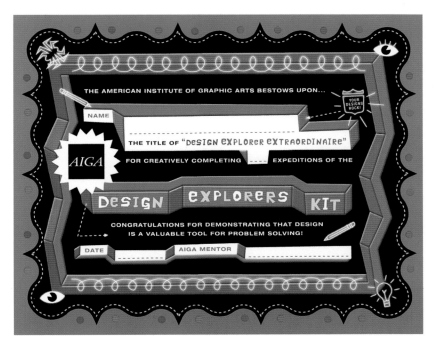

above: When the design expedition is finished, children have learned a lot about graphic design, problem solving, and themselves.

"My least favorite color is white because it matches anything." Tabitha, age 8 1/2

Design of the Package

Chris: The design of the kit's box was really important, too. Most consumer products for kids have to be attractive to parents and children. We wanted this to be just for the child because parents are not involved in purchasing it; it is distributed free to schools and after-school programs. Through research of television, *Nick* magazine, and animated shows, we were finding a bad-boy attitude was prevalent. We tried to find some middle ground in the design and develop something with attitude.

Bill: We wanted the child to look at the box and have his imagination go wild. It was also important to pump up the contents a bit: We didn't want a kid to open a plain box and say, "Oh, great. It's a pencil and some rubber bands." We want them to see that the experience will be a lot more fun once they begin working.

Chris: Although it has an element of rebellion, what we are offering is safe and fun. We're giving the children license to do things they've never done before. The illustrations on the box give them the ability to imagine what they might be. I can design a building. I can design my own money.

Beth: In the end, we hope the kids are learning to work on teams, feel confident with themselves and their ideas, and that they have a sense of belonging to a particular group. We want them to know they can take charge of their dreams. This our chance to be a great role model for the applied arts. Design is a problem-solving process: I hope we are giving children a toolbox for solving problems through their entire lives.

AIGA Design Explorer Kit © AIGA
Beth Singer: Chair
Bill Gardner: Director of Design
Jodi Bloom: Director of Volunteers
Susan Merritt: Director of Curriculum
Chris Parks: Designer and Illustrator
Sam Shelton: Director of Logistics, Special Advisor to the Chair
Howard Smith: Director of On-line Information
Funding through AIGA's Siras Greiner Fund, created to support thoughtful interaction between designers and children.

Candlewick Press

Anyone with children in their life has probably read at least one or two Candlewick Press books to their favorite small people. In fact, if the reader is a designer or illustrator, that number is likely much higher. The exceptional level of design and illustration in Candlewick books is a natural draw for anyone, but for those in the arts, it's irresistible. The publisher's list contains Newberry Award–winning titles such as *Because of Winn-Dixie* and other award winners such as Helen Oxenbury's *Alice,* Inga Moore's *Wind in the Willows, Weslandia, Where's Waldo?,* and the other *Waldo* books. The many more on the best-loved list include *Guess How Much I Love You, Farmer Duck, Can't You Sleep, Little Bear?* and *The Christmas Miracle of Jonathan Toomey.* Every book is crafted to tell the best story possible. Art director Chris Paul and associate art director Ann Stott talk here about what makes a book resonate in a child's life.

Chris: The picture-book creation process at Candlewick is probably a bit different than at other publishers. It is a collaborative effort. The author, editor, art director, designer, and illustrator all work together to make a book. The resulting design element in a picture book should be silent. It should blend so completely with the art that the match is seamless. Designing a book is not like designing a catalog or an ad where the designer forms the entire project.

We start with the text, meeting with the editor to talk about the philosophy of the book and the target age for the book. Then we ask an illustrator how he or she would like to illustrate the story. It's the illustrator's job to extend the story beyond the text, to bring the text to life. We think about a mother or father reading to his or her child, about the page turn or pacing.

Ann: Pacing a book is all about timing. You don't want all of the action to take place on the first two spreads. Instead, the story should build to a climax. It's like seeing a minimovie in your head.

Chris: We make a lot of dummies in working out the page turn; we want to make sure the story unfolds such that the reader is involved on every spread and that the bigger moments in the story get the proper amount of visual space.

Ann: When I design a book, I design for the child, but it definitely has to appeal to the parent, too. That's easier these days because kids today can take in more sophisticated art. They are bombarded with all sorts of visual stimulation today, so they are able to appreciate more and different styles. Over the past few years, we have broadened our illustrator choices to include people not necessarily regarded as children's book artists.

Chris: More and more artists are interested in doing children's books. The children's picture book really is an art form and can be a rewarding experience for an artist. A good illustrator will bring different levels of meaning to a book. Of course, not every child will understand every level, but they will make connections with some of them.

Thinking about a big bird with big teeth
who might swoop down and carry you away

is scary.

Universal Themes

Chris: To connect with kids, we want our books to deal with universal themes. Recently, we did a book called *Max*. Max is a superhero kid from a superhero family. I had the opportunity to read the book to a four-year-old boy recently, a child who had no frame of reference for what a superhero is. But he really responded to the book. First, it's funny, and, second, it tells a story about a baby superhero who can't fly like the rest of his family. It's about being small and addresses the universal need of every child to be bigger and to be able to do what others do.

Ann: The element of fantasy and a strong main character are also important in picture books. *Weslandia* is a perfect example. It's about a boy named Wesley who doesn't fit in. One summer he creates his own civilization in his backyard. He does his own thing and, by the end of the book, he has lots of followers. Combining real-life issues with fantasy is one way to reach kids. They can relate to the main character and find comfort and ways of coping.

Chris: Humor is good, too. Kids always respond to humor, even if it's a bit raunchy or slapstick. Anything that talks about outrageous behavior really catches their attention.

Ann: Kids love to pretend, especially three- and four-year-olds, who are busy exploring different roles and love to imagine that they are somebody or something else. Our books create magical worlds for kids.

above and opposite: A successful children's book does not have to be all sweetness and light. *Some Things Are Scary* is about all kinds of things children really worry about—grabbing the hand of someone who is not your mother, fearing that you will be the last one picked for teams, climbing up a tree and not remembering how to get down. The remarkable illustration style used in the book is an emotional match to the subject matter.

right: Connecting with a child's true feelings makes a book an instant hit. In *Weslandia*, a boy who doesn't belong starts his own fantastical civilization. The situation and illustration is over the top, but the emotion is a real one.

Weslandia. Text copyright © 1999 Paul Fleischman. Illustration © 1999 Kevin Hawkes. Reproduced by permission of the publisher, Candlewick Press, Inc., Cambridge, MA.

Uninterested in traditional sports, Wesley made up his own. These were designed for a single player and used many different parts of the plant. His spectators looked on with envy.

Realizing that more players would offer him more scope, Wesley invented other games that would include his schoolmates, games rich with strategy and complex scoring systems. He had to be patient with the other players' blunders.

Chris: We've also found that if these characters are depicted as animals rather than humans, children respond more favorably. Most of our best-sellers have animals as their stars. They're just more universal. You might show a little boy with red hair and freckles in a story, or you could show a chipmunk. The child will probably respond and relate better to the chipmunk.

We talk a lot about what the child or adult will respond to best. Covers are important in this regard. Because we are a trade publisher, not an educational publisher, the overall look of the book is crucial. It has to stand out on the shelf in the bookstore. The cover has to be immediate and striking. It has to say, "Pick me up and look at me."

Ann: The book jacket is, in fact, the advertisement for the book. Before the sale, it has to stop consumers and entice them to pick it up. After the sale, it has to make the child want to pick it up and read it again and again.

"I like illustrations in books that the artist makes look real in a way and not real in a way." Ken, age 10

above: Children do not have to be wooed with bright colors in order to gain their attention. In *Zachary's Ball*, black-and-white illustration and muted colors on the cover are a perfect match for the nostalgic story of baseball magic.

Zachary's Ball. Copyright © 2000 Matt Tavares. Reproduced by permission of the publisher, Candlewick Press, Inc., Cambridge, MA.

Ann: *Kennedy Assassinated* was written by Wilbourn Hampton. He was a cub reporter on his first job in the newsroom when the news of the assassination came in. It gives kids the historical facts, but they are presented in a fast, action-packed way. The author's viewpoint was key to the success of the book. It may also make kids think about a career in journalism or want to find out more.

Chris: Some nonfiction books use photos, if they are available and appropriate, and others use art. Stories that are more atmospheric and poetic can use art.

Ann: Illustrations can bring nonfiction stories to life in a way that photographs cannot. You have more freedom with the picture content when a book is illustrated.

Chris: We walk a tight line here, though. Most nonfiction books are for older children and, if they are illustrated like a picture book, children as young as seven, eight, or nine won't pick them up. They don't want anything that looks like a baby book. Therefore, the format of nonfiction is carefully considered.

It's important, too, to acknowledge that not every child will understand every level of a story or an illustration. Every child is different; you can never anticipate what will be a hit. The best children's books really appeal to everyone, adults and children.

Ann: There is so much out there for kids today, so many influences. If our books slow them down, make them stop and look at things more closely, and make them ask questions, then the book is doing its job. If they entertain and comfort, it's even better.

left: *The Greek News* and *The Roman News* use a format familiar to children—the newspaper—to introduce unfamiliar topics from history. The twist makes nonfiction topics (the series includes *The Aztec News*, *The Egyptian News*, *The Stone Age News*, and others) come alive for young readers.

below: Candlewick designers call sentimental books like *Guess How Much I Love You* a "grandmother purchase." They are sure to be a hit with parents and adult relatives of small children.

Guess How Much I Love You™. Text copyright © 1994 Sam McBratney. Illustrations © 1994 Anita Jeram. Reproduced by permission of the publisher, Candlewick Press, Inc., Cambridge, MA, on behalf of Walker Books Ltd., London.

right: Books for older children, like *The Tiger Rising*, can use more symbolic, less specific art.

The Tiger Rising. Copyright © 2001 Kate DiCamillo. Cover illustration © 2001 Chris Sheban. Reproduced by permission of the publisher, Candlewick Press, Inc., Cambridge, MA.

"All of the *Little House on the Prairie* books are good because the ilustrations really show what was happening. Jamie, age 10

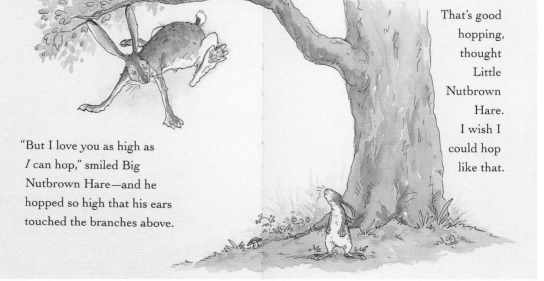

"But I love you as high as *I* can hop," smiled Big Nutbrown Hare—and he hopped so high that his ears touched the branches above.

That's good hopping, thought Little Nutbrown Hare. I wish I could hop like that.

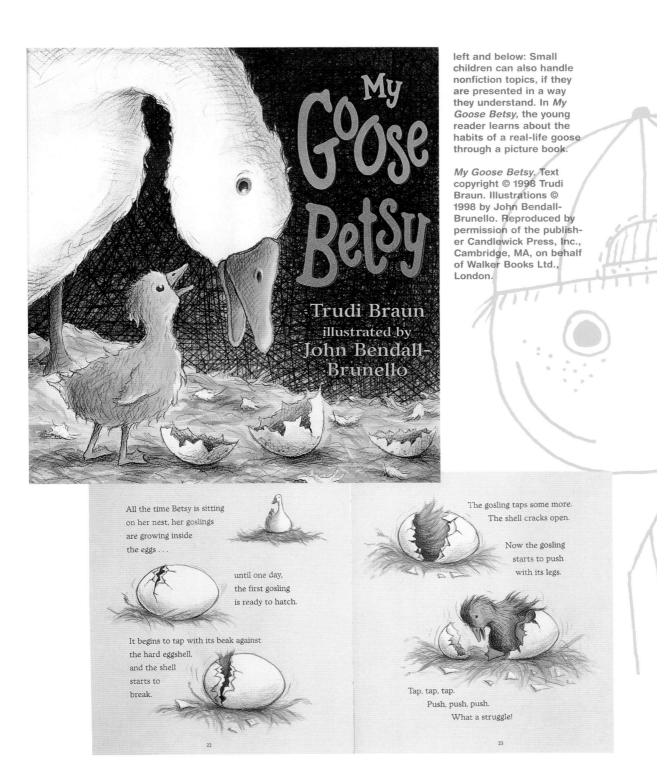

My
Goose
Betsy

Trudi Braun

illustrated by

John Bendall-
Brunello

All the time Betsy is sitting on her nest, her goslings are growing inside the eggs . . .

until one day, the first gosling is ready to hatch.

It begins to tap with its beak against the hard eggshell, and the shell starts to break.

The gosling taps some more. The shell cracks open.

Now the gosling starts to push with its legs.

Tap, tap, tap.
Push, push, push.
What a struggle!

22

23

"Harry Potter is good because his books have a large amount of fantasy. I believe children should have fantasy in their lives." Chad, age 10

4 &

AGE CUES, DESIGN CLUES

year

Age Cues—Design Clues for 4 to 5 year olds

Four- and five-year-olds have the same curiosity about the world as toddlers, but they also have the refined motor skills that allow them to create more experiences on their own. Many are adroit computer users and game players. Boys and girls now recognize standard sex roles—girls are mommies, boys are daddies. Some embrace these roles enthusiastically while others fight them. All children this age, however, love to imitate grown-up activities. Designs that permit pretend but real-feeling experiences are a hit.

MOTOR AND PHYSICAL DEVELOPMENT

With four-year-olds, small motor movements are becoming much more refined.
• Games and toys can be less chunky. • The child can usually hold a pencil or crayon properly, so drawing skills can be encouraged.
Four- and five-year-olds can play in ways that require more body control.
• Design can encourage running, jumping, hopping, and skipping. • Dance and music are popular. • Designs can require balance.
Can recognize and replicate patterns and rhythms. • Designs can rely on a child's memory of procedure and of physical patterns. • Developing artistic skills can be called into play. • Tracing is possible.
Increased eye-hand coordination. • Board games become popular.• Jigsaw puzzles, bead-stringing, and other fine-motion activities are fun.

SOCIAL SKILLS

Prefer gender-appropriate activities like role playing. • Dress-up clothes and smaller versions of grown-up designs encourage pretend play. • Designs should allow children to imitate adults in their world—mother, father, teacher. • Introducing nontraditional roles may not be successful.
Like to play with other children, sometimes competitively. • Simple games that allow two or more children to play can be designed. • Activities that work toward a common goal may succeed. Example: building a castle with blocks.
Can separate themselves mentally from physical surroundings. • Designs can encourage pretend play. • Designs can put forth absurd situations—a balloon farm, for example—and children will accept them.

INTELLECTUAL AND COGNITIVE DEVELOPMENT

Can think logically. • Toys, games, and books can require simple strategies and memory.
Know eight basic colors. • Designs can mix colors. • Designs can encourage children to experiment with new media like wire, cork, string, yarn, pipe cleaners.
Memory is developing. • Designs can include patterning. • Activities can have defined-but-simple rules.
Sometimes are mentally many steps ahead of their physical selves. • Designs should simplify more advanced activities. Example: Play car console allows small child to "drive."
Become interested in writing and words. • Activities that involve paper and notebooks for writing. • Designs can include labeled pictures and words that describe objects.
Self-esteem is developing. • Designs should reinforce a child's ability to succeed on his own • Designs might include some capacity for reward. Example: A certificate can be printed after children complete a computer game.
Can understand clear differences between own opinion and those of others.
• Activities can involve choices based on opinion. • Toys can encourage cooperative play.

MEDIA

There's no doubt that children today are extremely media savvy. They are not only able to absorb tons of information, they have the know-how to manipulate the channels of delivery—mainly, television and the Web. In an effort to not offend anyone, however, many shows and sites are extremely watered down with respect to design and content.

Some do excel, however:

Zillions: How a print publication made the successful transition to being completely on-line.

Teacher's Pet: Illustrator Gary Baseman brings his powerful illustration and communication skills to the television screen in a new Saturday morning show.

Noggin: An educational channel and on-line site where true collaboration between television and the Web exists.

WillingToTry.com: Designers at Funny Garbage show children how to look at their world in new and wonderful ways.

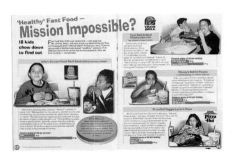

Zillions

In September 2000, the consumer education magazine for kids, *Zillions* (from Consumers Union, publishers of Consumer Reports), ceased publication. In its place grew a new Web site. The transition was not unimaginable in the world of magazine publishing: With paper, printing, and postage costs soaring, an electronic publication makes good business sense. But how would the new *Zillions* (www.zillions.org) serve its young readers? How would the magazine's and, later, the Web site's creators learn to serve in new ways? Art director Rob Jenter and editor Charlotte Baecher share their insights.

Images on this page copyright © 2000 (above) and 1998 (below) by Consumers Union of U.S., Inc.

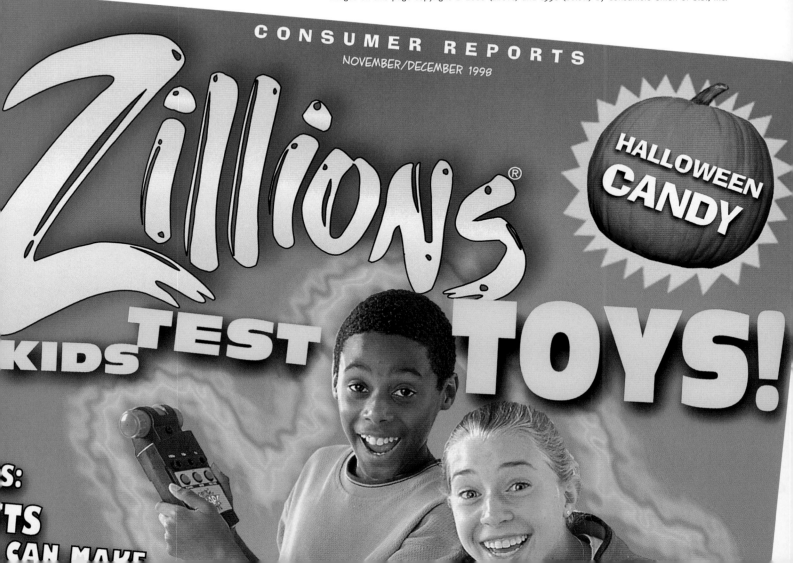

Images on this page copyright © 2000 (above) and 1999 (below) by Consumers Union of U.S., Inc.

Charlotte: It's obvious that you can't take a magazine and just drop it onto a Web site. A Web site is an active relationship. There, you are constantly looking for ways to engage and interest kids in a more immediate way.

Rob: Our job is to educate kids about consumer issues and give them an awareness about advertising and media messages that are being pushed at them. When a Web site became an option, we saw a way to get our message to kids in another way. For instance, now we can go for different age groups. Originally, the magazine was for 8- to 12-year-olds. We had a limited number of pages and had to devote real estate to a specific group. Now that we are doing a lot of interactive things on the site, we draw 14-year-olds and older. We can put up more pages and target different groups.

Charlotte: We've experienced changes on every level. First off, we have a much better opportunity to be timely—we can test scooters in August and have the results on the Web site in September.

Rob: Toy trends change very quickly. It used to be that by the time you got a toy test into a bimonthly issue, that toy might not be hot anymore. Even a monthly cycle would be too slow. Speed is the main advantage with the Web.

Charlotte: It's a blessing and a curse, though. We can give better service, but there really is no downtime. Also, we are learning our limitations. In a lot of ways, our eyes are bigger than our stomachs. We would love to do quizzes, but right now we don't have the ability to check children's progress. If they pick the wrong or right answer, we want them to know that.

Interactivity Factor

Rob: We do have a number of interactive pages that ask kids for feedback about television shows, toys, and so on. Those are very important. All of them have comment fields, so we can actually monitor what the kids say. And a lot more children respond to these than they did to the magazine's Letters page. We post the answers on the site, which is another great way to provide feedback for other kids.

Charlotte: Kids can also send in their own money problems or experiences, and other kids can respond with advice. So the kids are learning and being entertained—they aren't passive like they are when reading a magazine.

Rob: Kids' sites have to do more visual things than regular magazines; they have to be more colorful and playful. But there's a price you pay for that. You're hampered by download time and how much space a picture will take up. So you can't do the same things visually that you did in the print publication. But you can keep the same flavor.

Another thing I've learned is that kids approach the Web differently than adults do. They just try things—they don't read instructions. You don't need to provide as much navigation for them.

Charlotte: We also found that we were using far too many words. In the magazine, we were using lots of leads and decks to get kids interested in reading a particular article. But when we tried to do the same thing on the site, it was too much. Those first five words on the screen really must convey the benefit to the reader. We just couldn't always be creative and cute, like we had in the magazine. The articles can't be too text heavy either. Kids won't scroll down through page after page of words.

Zillions was a print magazine published by Consumers Union, which also publishes *Consumer Reports,* until September 2000, when it went online as a Web-based magazine. The print publication was popular with children interested in consumer education—at its height, circulation was 270,000 subscribers—so the magazine's art and editorial staffs worked hard to create a Web site that had the same appeal.

"I get two dollars allowance. I think."
Kayla, age 8

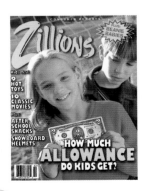

right: With children, interactivity is crucial. Features like Ad Patrol let site visitors be in control and, in essence, contribute to the content of the site.

far right and below: While the print magazine allowed the *Zillions* staff to dedicate two or three spreads to a single article, the Internet allows them to include more information and give it more breathing room.

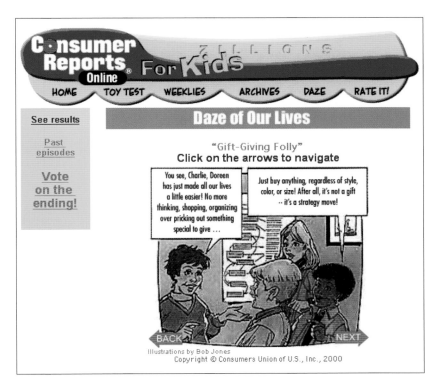

Illustrations by Bob Jones
Copyright © Consumers Union of U.S., Inc., 2000

left: Some regular features from the magazine have been continued on the Web site, including Daze of Our Lives. But it is an improved comic strip on the Web; not only can visitors go back and read past installments, they can also vote on the ending of story lines.

below: Linear operations like the steps outlined in "Build a yummy TV burger" are idea for page-to-page clicking. Child readers can take in one piece at a time

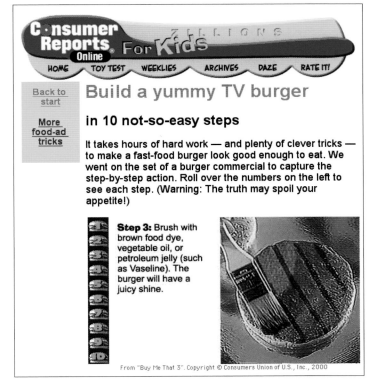

From "Buy Me That 3". Copyright © Consumers Union of U.S., Inc., 2000

"Now that I'm smarter and more mature, I usually save my money." Jamie, age 10

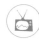

I also think it's important for kids to understand where they are. Where are they going to next? Where are they coming from? You have to have clear and easy navigation so they can easily go forward and back. They are in control.

Content Is Key

Rob: My entire bias is toward getting things clear and easily understood, playful but not confusing. In the early 1990s, we had a sister publication in Great Britain called *Check It Out,* for 15 to 16 year-olds. It tried to do everything with a very far-out philosophy and tried to be hip. But it was too trendy, even for kids. Certain design principles have to be followed; you can't ignore them all because you're designing for kids or for the Internet. Take, for instance, game magazines for kids—some of their design makes it hard on the reader. Why do that?

When we did a print product, we would go to schools and get feedback from kids on specific covers, and we discovered that it's hard to take solid information away from them. We could never determine if a cover was more popular because it was a better color or the image was more interesting or whatever. We could never figure out what worked best.

It turns out, the content was always the key thing. And the Web site also turns out to be much more content- than design-driven, right now at least, due to technical considerations. I would love for kids to be able to see a movie of a toy test or take a 3D look around a toy. All of those things will happen at some point, but for now, we are concentrating on solid content and lots of fast feedback. The excitement and interest have to be there, but they have to work within the message of the content. Kids are looking for more and more content.

As a designer of an on-line publication, you have to do more than you want to do. There is no downtime. And you have to keep rethinking things. For instance, to get started with the Web site, we were trying to stretch our materials, so we put up some past articles from the magazine. A kid wrote in to say that he remembered seeing a specific article in the magazine, but that he thought it was a great idea to put it on the site for all the new kids who might visit the site. We were trying to fill, but he saw it as trying to share. It's a new way of thinking. (A link to *Zillions* is available at www.Consumer Reports.org)

left: Surveys allow visitors to vote on subjects of concern to children, and they allow young readers to learn what other people their age are thinking.

below: *Zillions* designers and editors are working in more animations to show products in action. In the future, they would like to also include actual toy testing and other action footage.

WACKY Card #901

Wacky
Links:

Past
Wacky
Cards
and
Photos

Donkey Con, that psychopathic primate, is back, with a new sidekick, Diddy Con, in a crazy jailbreak adventure! (continued below)

Illustration by David Boelke

"I saved my money for a china figure of a mother reading to her baby. It was worth it." Hali, age 10

Teacher's Pet

Gary Baseman has long been recognized as an illustration phenom. His surreal characters and visual ruminations appear again and again in mass media, in places as disparate as *Time* and *Raygun* magazines and the new hit game Cranium. He is a natural storyteller, which perhaps explains why he has pursued a distributor for an animated version of his work for many years. In 1999, *Teacher's Pet* was picked up by Disney, and in September 2000, the show hit the air. Although *Teacher's Pet,* a cartoon about a boy and his dog who disguises himself as a boy, is perched in the middle of ABC's Saturday morning lineup of cartoons, Baseman does not feel that he is illustrating for children alone. The quality of his work and that of the writers and producers creates a television product unlike anything else available.

Gary: First, the look of the show is not derivative of other Saturday morning animated shows. It is a labor of love, and its look really is based on my paintings. It follows my artistic approach to the point where the characters look like my characters. All the backgrounds are painted on canvas.

The writing is not your typical Saturday morning fare. My partners, Bill and Cheri Steinkellner, are wonderful writers. They are telling real stories with real humor. Music is used to heighten and push the story; we use a lot of classical music and opera. We are not doing feature animation, but we do as full an animation as possible, from the Bob Clampett comedic timing to special posing to a cast that is a wish list for a prime-time show—Nathan Lane, Jerry Stiller, David Ogden Stiers, and Debra Jo Rupp.

So we, as adults, are all creating a show that we enjoy. We are entertained by it and we learn from it. Kids love it the same way, and, we hope, are challenged by it.

What's challenging about working on a kids' show is that society is protective of kids to the point where stories can become bland. They don't want to upset anyone. Some animated children's shows end up being safe and boring. The wonderful thing about *Teacher's Pet* is that we are not drawing down or talking down to kids even though we are still working within the standards of being an educational show. My crew works really hard to maintain a level of content that evokes some truth about the human condition and still has fun.

Spot On

Our main demographic is probably the 9 to 12 year old, but the show is for the whole family. The main character, Spot, is a dog who wants to be a boy. He is bored at home and wants to go to school like his master, Leonard. So he puts on Leonard's dirty clothes, a pair of glasses, and a beanie cap. He enrolls at school as Scott and ends up being the smartest, most popular kid/dog at school. He is constantly quoting Shakespeare, Dickens, and Lincoln, and the girls all think he is dreamy.

Leonard, on the other hand, dreads school because his mom is the teacher and he doesn't want to be seen as the teacher's pet. When he discovers his dog is at school, he finds himself in competition with his and man's best friend.

A lot of the show is us watching Scott experience things for the first time—his first Halloween, his first time in a supermarket, his first love, his first pizza that he didn't pick up off the floor.

The show is at its best when we are able to play off our characters' insecurities and strengths. They are able to learn to settle their conflicts through their friendship. It is a buddy show—about a boy and his dog who is disguised as a boy. They are growing up together. They care about each other and know how to push each other's emotional buttons. They test

above: Illustrator Gary Baseman's foray into television animation resulted in *Teacher's Pet*, a Disney production about a boy (Leonard) and his dog (Spot) who is pretending to be a boy (Scott). The art is true to Baseman's wonderful style of illustration and sense of humor.
©Disney Enterprises, Inc.

opposite: *Teacher's Pet* shares the travails of two friends who know each other's strengths and weaknesses. Young viewers identify with the characters because they go through these experiences with their own siblings and friends.
©Disney Enterprises, Inc.

each other's strengths and insecurities, just like real children do to each other. We don't serve up the same cliché situations.

When I create illustrations for kids, it is important to intrigue them with a powerful image. I want them to think and feel—which, to me, is basic communication theory. I want the show to linger with them, to affect them intellectually and emotionally, and for them to use the lessons they learn. Obviously, with kids, we keep the message a bit more positive and directed to children. But it should still be real.

Dreams and Concepts

One thing that I really enjoy are the dream sequences in the show. A character drifts off to consider the ramifications of a situation, and the scene becomes surreal. When I create one of my paintings, I always try to push my intellectual side and challenge the intuitive. I use more symbols and color to evoke what isn't obvious. I believe that's what happens in the dreams. These are abstract and intriguing. They end up challenging the way a child sees something, to expect the unexpected.

right: Although backgrounds in the cartoon are kept deliberately empty to keep viewers focused on the characters, Baseman does take advantage of opportunities like this set of lockers to subtly reveal more information about individual characters.
©Disney Enterprises, Inc.

Kids don't want to be bored; I don't either. If a character is thinking about something, we won't take the radio show approach where he just stands there and has a monolog. Instead, we'll add conceptual scenes, just like I would do in an editorial illustration. Another head may pop out of his head or his head will open up or a little version of him will pop out and start whispering in his ear.

What's most important is telling a good story that both children and adults can enjoy. The whole show can't be surreal, or it would be like an experimental film. For me, the goal is to be complete and consistent and to feel satisfied with the experience in the end.

Complexity is another issue. How complex can art for kids be? I can draw things that are pretty complicated. I remember doing print campaigns for Gatorade and other children's product clients that were very complex paintings: They know kids will spend lots of time with print art. But with television, I want to concentrate on the story unless we are using a background as an establishing shot. Our focus should be on the character, and the background should highlight his emotions.

above and right:
Baseman says that one
of Scott's real attractions
is that children get to
anticipate and watch his
emotional first experi-
ences with things like
first love, ice cream
cones, Halloween,
and Scouts.
©Disney Enterprises, Inc.

"Catdog is the dumbest show—it seems to be on forever. The sounds get annoying. The voices get annoying." Alina, age 9

right: Note how much the show's art is like an actual Baseman painting, with brush strokes and canvas showing through. The frames are actually created electronically overseas by Japanese animators following Baseman's instructions.
©Disney Enterprises, Inc.

below: Another fun aspect of the show is Baseman's warped sense of forced perspective.
©Disney Enterprises, Inc.

"There's this one really dumb show where they have an Antarctica snow tiger in the show that takes place in Florida." Zack, age 10

The characters' bedrooms are a good example. Ian, for instance, is a wonderfully disgusting kid who thinks he's brilliant. I had the pleasure of spending a whole weekend designing his room. He collects his toenail clippings, earwax, and scabs. He has roach motels with real roaches under his bed, a lounge chair made out of hardened bubble gum, and Hardened Cholesterol Man. A branch with a beehive and bees sticks right into his room. This is visually complex.

Another way we make the show more emotionally real for kids is to make it abstract. We can push the emotion of the situations by using strong colors or even by collaging ripped paper. We can keep the details limited and the palette down to a few colors. We use music to emphasize the emotion of the moment: If you are supposed to be in terror, you will be terrorized by the music. If you are supposed to be in love, you get really rich, romantic music.

Teacher's Pet is a joy to work on. It's a joy every day to come in and work with my crew. With my own art, I like to keep myself fresh and inspired. I want my staff to feel that they are growing and always challenging themselves, too. When we're successful, everyone benefits from the product.

Noggin

Noggin, a true multimedia project, is a television network and a Web site, with more formats to come. Formed as a joint venture of Sesame Workshop and Nickelodeon in 1998, Noggin launched on television and on-line February 2, 1999. The television component has enjoyed the quickest uptake of any cable channel and is available on Digital Cable Systems and Satellite TV. The Web site, of course, is available to everyone all the time. Noggin's creators work hard to build what they call "pitch and catch" between the computer screen and the television screen. One is not subservient to the other.

Noggin's premise is simple: If kids are learning about something they truly care about, then it is likely that they are having fun. Kenny Miller, vice president for programming and production, shares how Noggin is accomplishing its goals through design.

NOGGIN

SEARCH · VISIT MY HOMEPAGE · SHOUT · HELP · THE WORX · LOG IN

JOIN NOGGIN

PLAY
ON THE TEAM'S
Fantasy Baseball
Game!

MAKE
YOUR
OWN
ANIMATION!

The
Hubbub

THE
WORX
has it all!
Click to see.

JOIN
noggin

Can
YOU
crack
the
case
BEFORE the
Ghostwriter
team?

NOGGIN

"if I were
there..."

Click here to get
NOGGIN FOR LITTLE KIDS

Kenny: In creating Noggin, we work with all sorts of design: visual design, sound design, interactive design, and its older cousins, industrial design, education design, and editorial design. All of these add up to something that people call brand. But for Noggin to really succeed, we need to go beyond these categories and think about something that is clearly new to the world—convergent design, building experiences that live online and on air into our network from the get-go.

Our producing teams spend their time building shows that come from a kid point of view, what we call "kid-driven learning." One of the ways we do this is to make shows that live simultaneously on television and on the Web. The Web site is not a supplement to television. It is a place where we let kids get in on the act of making Noggin. This might include using our animation and audio tools to make a creative work that will show up on television, or going behind the scenes to get more of the characters and narratives that are on our television shows. Everything we do connects our TV network and our Web site together as closely as we can.

Not Wacky, Just Smart

We make things for kids 8 to 12. Typically, the only television these kids watch is pure entertainment. At Noggin, we try to make shows and software that entertain but that also have baked-in learning. Now I don't mean shows about math starring some wacky professor. Instead, we provide a place where, when kids come home from school, they can chill out and push their brains ahead at the same time.

The visual and sound design of the channel and the Web are coordinated. This is most evident in the way we help kids navigate our site and our air. On television, we have a set of menus and bumpers that help kids know what is on and what is coming up next. The look and animation of this is shared directly by the look of our navigation on the site.

We acknowledge the stature of anime [Japanese animation] and skateboard graphics in the lives of kids. Our look references those palettes, shapes, and colors. We also use a futuristic look. This is a part of our message. In the future, you will make and control your media any way you like, and your media will help you activate your brain rather than turn it off. That's what we're starting to do right now at Noggin.

opposite: There's lots to explore on Noggin's Web site, but its splash page doesn't overwhelm. The design is based on circles. On the Web, where most designs are based on right angles, this is a much friendlier look.

above: The Worx is where the real content of the site reveals itself. Children can play games, check out what's on Noggin TV, or even contribute to the Web site and channel with their own creations.

right: Radio Noggin is a unique, on-line radio program where children make the music and "sound-scaped" stories using sophisticated mixing tools. Some of the music and sound stories created by young listeners is actually broadcast on the station.

Elements of Design

We really work hard on the Web site's front page. Kids love it, but they want to know everything that is on the site, so we are working on an update that will merge the look of our front page with the variety represented with a site map. We have to balance showing all the stuff on the site with not overloading kids with a lot of noise in the page, and still manage the download size at the same time.

Our current design is based on circles. On the Web, everything is tables and squares. This is the direct opposite—it's much friendlier.

Flash [animation software] gives us the ability to do more dynamic moves and layering, which lets us communicate with little text. Too much text is a huge turn-off for kids. Four sentences is too much for a single screen: The font ends up being too small, and that's not appropriate for kids who are still mastering reading. Typically, if you give a lot of instructions, kids won't read them. Then, if they get confused and can't do the activity, they're even more frustrated. With layers or art and animation, they can get the drop-down instructions on demand, but only if they need them.

I believe that the design of the network and Web site is not just a graphic look; it is a way of communicating with children. Communication is a dialog. The interactive design we are doing definitely engages kids in a creative, thoughtful dialog.

"In my family, my parents don't work with our computer or the Internet. But I do." Amanda, age 11

below: The Noggimation Quilt is another place where children can contribute to Noggin. After making a patch with art supplied on the site, the young artist may actually see his or her work posted on the Web site.

NOGGIMATION STATION

TODAY'S QUILT MAKE A PATCH QUILT STORY HELP!

SEARCH THE QUILT [] GO!

TODAY'S QUILT

What you see here are tons of YOUR sparks, ignited, animated, and patched together, to make

the **NOGGIMATION QUILT.**

Check it out, then make your own patch to add to the biggest spark collection ever!

Dinosaurs
JohnDoe, 12
NY

MAKE A PATCH

Click the arrows to see more of the quilt

right and below: The Hubbub reveals the synergy between the Noggin Web site and channel. Every night, two hours of simultaneous, coordinated programming and chat rooms are offered. Kids can watch and talk, respond to shows, vote on issues, and more. "In the future, you will make and control your media any way you like, and your media will help you activate your brain rather than turn it off. That's what we're starting to do right now at Noggin," says Noggin's vice president for programming and production.

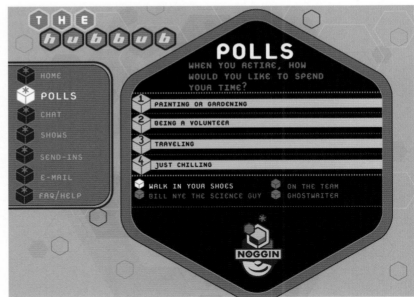

A Collaboration

The software we give kids on our site is unique. Our creativity tools give kids access to stuff that previously was only available on CD-ROMs. And our software is better because it's network enabled. That means we have technology to connect the television and Web servers, so animations that kids create on the Web site can go directly on TV. We don't need to do any video production, which is slow and expensive, to get kids work up on TV. This is the real beginning of many-to-many broadcasting. Already, we feature the artwork of fifty to one hundred kids on television every day.

On Noggin, kids can build their own home pages on-line, where they display stuff they made. They can also create communal works of art, such as making a patch for the Noggimation Quilt. So far, the quilt contains more than 150,000 animation patches made by them. A big part of the excitement for kids is that they are really cocreators of Noggin.

In the end, kids have busy lives—sometimes too busy. That's why the learning on Noggin comes in the form of fun they want to have. A lot of learning is important, but you don't have to call it education. We want to keep presenting unique experiences in unique packages, so Noggin will feel like a breath of fresh air to them. If we continue to do this right, the kids will keep helping us build Noggin, and we'll keep discovering how convergence works with our audience.

"I bug my mom for a laptop with Internet because that is the best thing I want in the whole entire world. With DVD." Zack, age 8

above: The Phred Show space on the Noggin site reveals how the ideas and concepts introduced on the TV channel can be expanded upon. It has more content than the channel offers; it is not a repeat of the show.

right: Noggin.com offers lots of games to play. The art is often absurd and is always colorful.

Funny Garbage

Funny Garbage, an interactive design firm, burst onto the scene only four years ago and, almost immediately, it was making meaningful contributions to the field of interactive design. From Cartoon Network and Comedy Central to the LEGO Company, NASCAR, and the Warner Music Group, the firm's clients are relentlessly high profile. To understand the work the firm creates in designing for children, we interviewed Funny Garbage cofounder John Carlin on a much smaller project, Willing-To-Try.com. Created for a Japanese educational group to illustrate its philosophies, Willing-To-Try.com is a charming exploration into how a human being—small or large—learns. Carlin also provides a reality check of just how serious the business of designing for children really is.

right: Willing-To-Try.com, created by Funny Garbage for a Japanese educator, is about learning to see the world and how to look at symbols and metaphors. It is a model of the founder's vision of tomorrow's interactive electronic storybook. Illustrated by Richard McGuire, the interactive module presents children with abstract shapes: a circle, a wavy line, or a set of straight lines. Here, selecting the circle allows the site user to blow bubbles, which turn into singing vowels. Other circle choices turn the circle into a deceptive moon or a hole with a tricky perspective.

John: Funny Garbage approaches design for children from two perspectives. One perspective is best typified by our work for Cartoon Network and Disney. It is a mainstream style. The other perspective is represented by Willing-To-Try. This is more of a vision of what things could be rather than what they are. Both points of view are intellectually valid. The former is better suited to paying the rent.

Willing-To-Try.com was an experiment in imagining what a children's book should be in interactive media—as if, in the not-too-distant future, parents sat down at their children's side at bedtime with a wireless computer. It's all about learning to see and how to look at different kinds of symbols and metaphors. My background is as an art curator and cultural historian, so I'm interested in visual thinking.

The figure on the site sees a line, and it might be the edge of a cliff. It might be a cane. The child chooses. It gives the child a different way to navigate the world and his environment through visual symbols.

Kids are entranced by the site. They like the imagination in it. But we are also taking things that kids like to do—blow bubbles, fly a kite, ride a bike—and making them live on screen. Its significance appears real to them because it relates to their real lives.

This is my vision for media, and not just for children's media. Funny Garbage is trying to maintain a fairly traditional sense of good content. Our job is to achieve the same depth as traditional stories, with profound emotion and execution, and to make it work on the Web—but not just as a series of linked pictures. Interactive design has to be something that is fundamentally interactive.

On Abstraction

One thing that makes Willing-To-Try.com work so well for children is that it is so minimal. Everything in their lives tends to feel like a too-busy American highway with too many billboards. Everywhere, a circuslike atmosphere is screaming for their attention. So we said, "Let's counter-program." I guess it's an easy trick, to just be quiet when everyone else is loud. But every good designer knows that minimalism is tough to pull off because simplicity is the hardest thing of all. If your line and character aren't compelling, there is nothing else to support it.

The site is abstract, but it is grounded in things that children recognize. There is a man. There is a ball. There is rain. If it were a true abstraction, just lines and circles, a child might enjoy looking at it, but it wouldn't be emotionally compelling nor, in the end, intellectually stimulating.

above: Selecting the tree option from the straight lines leads the child on a journey through a curious forest where magical letters grow on trees. Gathering the letters into prescribed words makes a host of animal friends and a bike appear.

below: The mirror option from the straight lines group opens a series of repeating mirrors. The character can see many images of himself moving in tandem with his own motion. Then, suddenly, one of the images stops behaving like a mirror and comes out of his frame.

right: Selecting the wavy line puts the character on the shore of an ocean occupied by somebody large. The wavy line can also be a string to a wonderful kite or the edge of a cliff. The difference is in how you consider the symbols.

Being Free

There is a remarkable freedom in working in children's media, mainly due to the absence of the façade of seriousness that adult culture has. You might think there would be more design restrictions, especially considering that we can't talk about certain things—such as sexuality and violence—but there really is more graphic freedom in terms of style. In adult work, the choices narrow dramatically; design must have a certain seriousness of color or line. But design for children is often the most vibrant thing in our culture. You will find that even artists whose work is not particularly kid-friendly are interested in kid media.

Consider Looney Tunes. These cartoons were really created to be movie trailers for an audience of children and adults. People today often consider them kid stuff—they've become part of low culture—but they are actually very sophisticated. These cartoons started a tradition that artists like Richard McGuire [the illustrator who created the Willing-To-Try.com character], Gary Panter, and Gary Baseman carry on today. Their work has remarkable appeal to all audiences.

My partner, Peter Girardi, and I grew up in the late 1960s and early 1970s, when the difference between high and low culture no longer was making sense. It used to be that art was considered "good" and pop culture and things like cartoons were "bad." But high and low culture are early twentieth-century perspectives. These terms don't fit our culture anymore. Plenty of adults like me learned about irony from Bugs Bunny. I learned a lot about visual culture from Disney cartoons.

This points out that, whether you're creating design for kids or adults, it must be content-sensitive to be successful.

right: Funny Garbage does other types of design for the children's market, including the Web site mark for CartoonNetwork.com. Founder John Carlin calls this a mainstream type of work, different from the exploratory design done for Willing-To-Try-com. Both are valid and worthwhile approaches, but while one is much more creative, the other type pays the rent.

right: Katbot is another Funny Garbage creation. A Web-based character who lives in a uniquely interactive environment that blends animation, multimedia stories, and interactive features, Katbot (at katbot.com, created by Angela Martini) offers children an engaging on-line experience. Unlike the standard two-dimensional site, which presents only a fixed segment of content, katbot.com is a live, 24-7 presentation of Katbot's daily life: It is more like a Web-cam site than a television show.

left and below: Katbot is a green, alien cat who is visiting Earth disguised as a foreign-exchange student. Children like her, Funny Garbage creators say, because she has an attitude problem and a "cute space pack."

"Game Web sites are the ones I like. Some games are learning ones that can help you in the end." Kevin, age 10

Fighting Similitude

My fear now is that we live in such a market-driven world, it's easy to become commodified. I mean, it's great that Levi's and the Gap have made it so we can all wear casual clothes to work, but now we all wear the casual uniform. There's even less diversity than there was before. Any sense of local culture is being eviscerated by mass marketing.

I think the question in the next decade, particularly when you consider design for kids, is how individual expression will find its way. We have to find ways to let kids, designers, and clients find their own space. People must come back in and redefine creativity. We need a breath of fresh air. Our perspective is how to maintain the identity of the individual. How do you preserve a child's sense of self in an overmarketed world?

Kids are growing up much faster today, or at least they seem to be. But the truth is that our culture is so sophisticated that people need much more time to master it. In the early twentieth century, mastery of culture was passed on through family and social groups. Later in the century, it was passed on by media. But now, media and even family life moves so fast that your hypothetical nine-year-old of today may need until his mid- to late twenties to master life and understand his part of it. He will need a period of incubation, even after he becomes an adult.

That's where storytelling through design will be important. It will help kids understand things like allegory and irony as well as their own history. The aesthetic pleasure of storytelling means that it will always go on. Designers—storytellers—must continue to study history and culture to help children understand it all.

Reality Check

To be successful in the field of children's design today, however, you have to have the design skill plus the ability to execute—have things done on time and on budget. This is a huge form of business; billions of dollars are at stake. Groups like AOL-Time Warner and Disney own more and more of the characters in our stories, and they are extremely cautious about how they are used.

Your first job as a designer is to understand this new landscape we exist in and then find your own place within it. Then look at the dumb stuff—the funny garbage, as it were—and ponder what makes it work. Why has it burrowed its way into our collective unconsciousness? Then try to claw your way back into art—into a sense of your own voice—but now in a way that resonates with the emerging realities of the new century. The classic design approach is to set your aesthetic coordinates and then translate them into your commercial work.

above: Young viewers can tune into Katbot's life, but they can also play interactive games, download Kat treats, and read journals and reports of the characters who are closest to Katbot, including Katbot herself.

left and below: One of Funny Garbage's animated shorts for CartoonNetwork.com is Zoo Force, a story about genetically enhanced food that transforms the ordinary animals of Zooniverse into the heroic Zoo Force, which is devoted to truth and justice. Children enjoy the bizarre characters and story line; they can relate because the short contains elements from their real lives. The illustration uses plenty of exaggeration, which allows the designers and illustrators to effectively communicate strong stories in a short amount of time.

"I like the Fox Kids Web site because they have fun games and cool stuff that kids like. I also like the Big Ideas site."
Heather 10 1/2

6 & 7

AGE CUES, DESIGN CLUES

Age Cues—Design Clues for 6 to 7 year olds

Six and seven year olds are as active as they are verbal. Personal expression—physical, verbal, artistic, and emotional—occupies an enormous amount of their time. Small motor skills are even more refined, so they can handle pushbuttons, crayons, mechanical devices like cranks or levers, small toys, and more with ease. Technology that scares grown-ups is exciting to them. Children are not proficient readers at this stage, but their ability to understand symbolic language and a greater range of colors is burgeoning.

MOTOR AND PHYSICAL DEVELOPMENT
Large motor skills are highly developed. Balance develops. • Activities should encourage running, jumping, skipping rope, dancing. • Competitive play and game activities are popular. Example: Who can run fastest?
Small motor skills are becoming more developed. • Crayons, scissors, markers, and other art supplies are popular. • More refined activities, such as weaving and building with small interlocking blocks, are possible.
Like to be challenged • Activities may combine physical activities into play. Example: rubbing head and patting stomach. • May want to be timed in activity as a gauge for measuring improvement.

SOCIAL SKILLS
Can work cooperatively with other children. Can wait for turn. • Sharing is possible. • Group games proceed without much adult intervention.
Can discuss topics as a group. • Activities that involve a group are appropriate. Examples: planting a garden, caring for a pet.
Can plan ahead. • Designs that allow child to decide "how much and how often" are now possible. Example: How many candies should I eat now, and how many should I save? • With children's better concept of time, designs can include some amount of delayed gratification. Example: Making a potholder on a loom, which takes time. • Can start and maintain collections.
Have empathy for others. • Books, in particular, can involve more sophisticated emotions. • Activities can involve concepts of fairness.

INTELLECTUAL AND COGNITIVE DEVELOPMENT
Develop deep commitments with people other than caregivers, such as teachers. • Designs can model relationships with others. • Activities should allow children to role play.
Prefer bright colors that create a pattern. • Use tessellations. • Use patterning and bright, contrasting colors.
Can read longer books. • Designs can include more complex language, story plots, and characters. • Designs can include theme.
Like routines. • Designs that perform predictably or at least in ways the child directs are comforting. • Consider designs that relate directly with a particular time of day. Example: A bedtime book.
Like to talk. • Activities should allow child to express himself orally. • Singing along with music and recording voice can be popular.

DESTINATIONS

Between the Internet and books, a child can go almost anywhere. This section concentrates on real venues and what makes them appealing to children.

All of these destinations have inherent elements of fun, but talented designers have heightened the interest of each.

Children's museums: An art director and a noted architectural firm share their ideas for creating an interactive learning experience.

San Diego Zoo and Wild Animal Park: Widely regarded as one of the top zoo and animal park venues in the world, this organization's marketing efforts are supported by energetic designs for children.

Ringling Brothers and Barnum & Bailey Circus®: How Big Blue Dot made the Greatest Show on Earth® relevant to children and families today.

Kids' Studio: "Go to your room!" doesn't have the same sting when it's a room designed by Kids' Studio.

Children's **Museums**

Designing exhibition graphics for children presents special challenges: interactivity, durability, scale, and even washability come into question. The Children's Museum of Manhattan (CMOM) faces these issues every day. This nonprofit institution was founded in 1973 to engage children and families in a partnership of learning through interactive exhibits and educational programs. More than 350,000 children and adults are welcomed to CMOM each year at its location on the Upper West Side of Manhattan. Working as design manager at CMOM, Carolyn Crowley learned to appeal to ages as young as one month. She has since moved to Lee H. Skolnick Architecture + Design Partnership, an architectural and design firm well known for its high-profile work for children and adults.

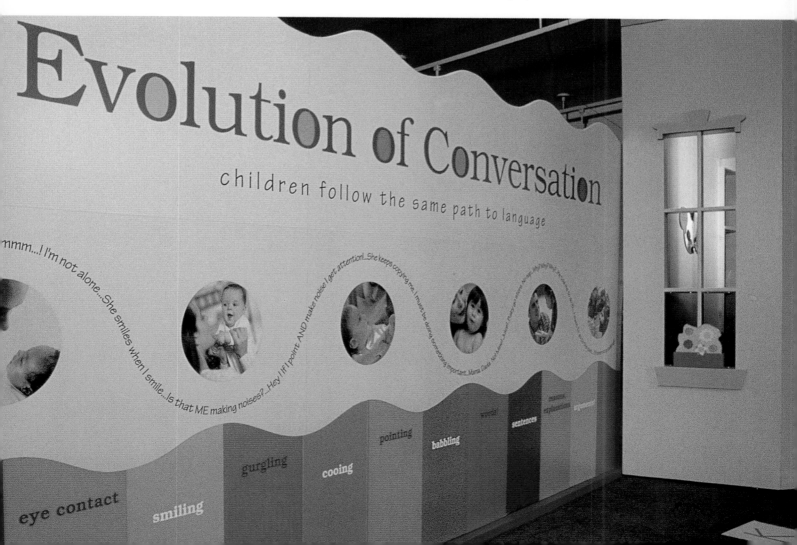

Carolyn: The main thing for me, when I design exhibition graphics for children, is to let the personality of the subject to come through. That's the same approach I use when designing for an adult; I just use the subject matter as my guide in choosing color, type, and design. A lot of designers might think that's odd. Some might push primary colors and such, but they are just operating off preconceptions. Designs that use too many styles, typefaces, illustrations, photographs, and information are designs that can overpower and confuse kids.

A good example is an exhibit I just finished at the Children's Museum, called the "Good Grief" exhibit. It uses *Peanuts*© characters to talk about conflict resolution, so I started visualizing colors that deal with that subject as well as colors that describe the history of the *Peanuts* cartoon strips. The color brown kept coming up. As I started to create the designs, I actually found that browns and purples worked very well with the *Peanuts* characters, which often have red and yellow clothing or accessories. When I suggested designing banners using brown, the idea was met with resistance, and I understand why. But when it makes sense to use colors that visually communicate the project's message, I do it.

Timeless Design

Another thing I try to do when I design for children is create something timeless. This is very important: An exhibit is often around for a long time, so you can't put a date on it like some commercial goods might have, say, if they are tied to a trend or a movie. Ageless has another meaning here, too. The design is for a broad range of people, from very small children who can't read yet to preteens to the parents who brought them to the museum. I have to appeal to everyone.

One practical way to do this is to keep text at a minimum and choose fonts that are classical and tasteful. We have to remember that children are trying to read on their own what we place in front of them. Some of these kids may be new readers, or the adult with them may do all of the reading. So we want to make it easy for them. Everything must be clear and legible.

Rugged Construction

Something else you learn quickly with exhibit design is that everything must be durable and washable. We always joke about it, but it's true. Materials we design with must be safe—they might get chewed on or run into. An object might get any manner of body fluid on it, but it still has to look nice after it's cleaned up. That's the challenge and the fun thing about a children's museum: They're allowed to touch everything. In a traditional museum, they can't do that.

Kids can also be destructive, although I don't think they mean to be. They are just being curious. Say you create a graphic on foam board: Kids will peel off its front. It's a universal thing. So everything has to be laminated. Plexiglas is also good to protect things, but any hard plastics we use must have rounded corners in case a child falls and bumps his head.

right: In the Chatterbug Tree area, also part of WordPlay, children can climb up and slide down or just hide out in the tree. Kids can also dress up in bird and cat costumes and discover role playing.

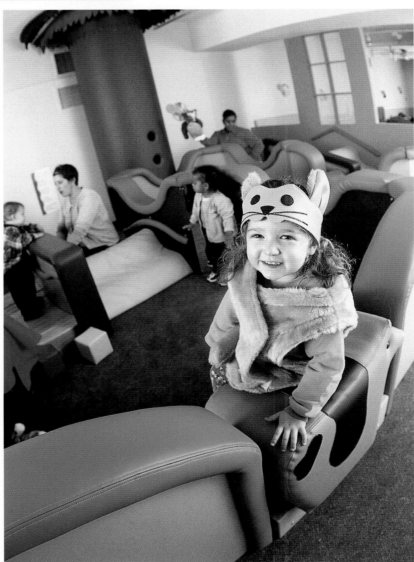

"I would rather have a trip to a children's museum than a new outfit. I hate to waste my time in a changing room when a museum has hours and hours of fun." Adrianna, age 8 1/2

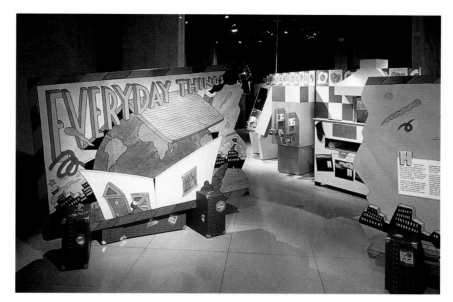

left and below: Earth 2 U is an exhibition done by Lee H. Skolnick Architecture + Design Partnership for the Smithsonian Institution of Traveling Exhibit Services. This hands-on show's goal was to make connections between people, places, and the environment. It sparks a child's imagination by, first, providing a traveling passport for each visitor. At each segment, passports can be stamped; by the end of the visit, the child has a passport full of colorful, informative stamps as a souvenir. Photographer, Maxwell MacKenzie

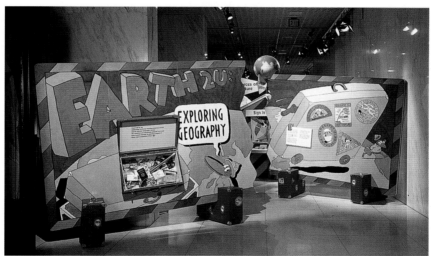

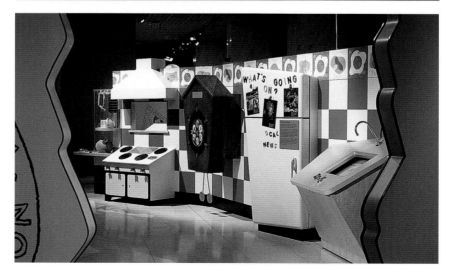

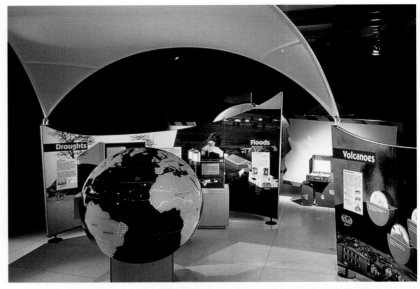

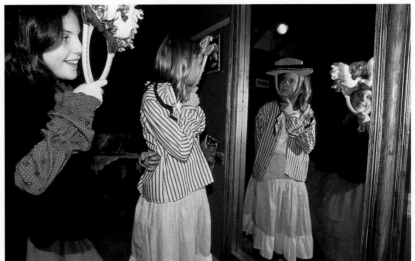

Of course, the scale of signs and exhibit space must be sized to children: Everything has to be about 30 inches off the ground. But you can have a lot of fun with scale: Kids love a room where they walk in and the carrots are bigger than they are. They can imagine that. In the Good Grief exhibit, the *Peanuts* characters are the same size as the children.

Floor Space

Museums are all about getting people to slow down and learn something. It might be just for five minutes, but that can be enough if the space is designed correctly. A children's exhibit should have enough space for kids to sit down and enjoy the interactive elements. This space must also provide room for adults to stand or sit and watch, and still leave room for others to get by. Kids don't want to feel rushed. They don't want to feel like they are losing their turn.

One thing that is always fun to do in exhibits is to create little areas that only the children can get into. It might be a series of holes that only small people can crawl into and be alone; grown-ups are too big. Children love to be able to crawl in and just sit.

Explorers' Park, in the WordPlay exhibition, is a good example of a space that is fun for children but reassuring to adults. It's for really small children, and, basically, it's an obstacle course. But the walls of the course are kept low and soft: They're made of Naugahyde, which is easy to clean, easy to replace, and comes in lots of colors. Kids can sit on the pieces of the exhibit, climb on them, whatever. The parent can cross over easily and come in if the child needs help, but the child is definitely still in a child-oriented space.

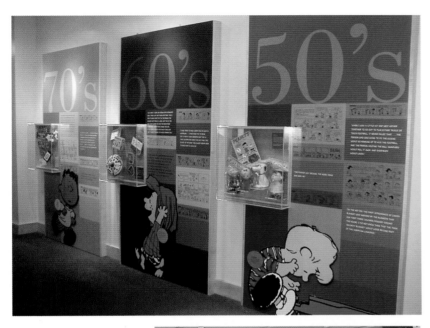

above: In the "Good Grief!" exhibit, an installation about conflict resolution, characters are made child-size—36 inches high. The historical perspective of Peanuts over the years is interesting to children and adults; the circular graphics next to each character lists personal traits. PEANUTS © United Features Syndicate, Inc.

right: The main exhibition area contains large three-dimensional characters on a baseball field. Using Charlie Brown as part of the typography is another playful touch that children can appreciate. PEANUTS © United Features Syndicate, Inc.

We always include plenty of puzzles and games in exhibits. Interactivity is also a big element today. A digital camera or computer might allow a child to create something and bring her interactive experience home. Exciting advancements in technology allow us to do this in exhibits today. The general concept of making something is powerful for a child. It involves them with the experience; they are an important part of what they see.

One of the best exhibits I ever experienced personally was at the children's museum in Chicago. There is a structure with an extremely high ceiling. In this space, you can take foam shapes and build a flying machine. Then you put your creation on a cable, use a lever to raise it way, way up, and it rolls off and flies. You can study it, see what makes the best flying machine. Aesthetically, the child gets to judge how his creation looks. Physically, he gets to build and control it. And because of the soft foam materials, safety isn't an issue. Everyone—small or large—has a tremendous reaction to the exhibit. It's one of those spaces where you can easily lose track of time.

I think, for a designer working for children, the best reward is being able to see kids interact with your design. You can see that you've entered their imaginations. You get to see for yourself if the work you've done is successful.

San Diego Zoo and Wild Animal Park

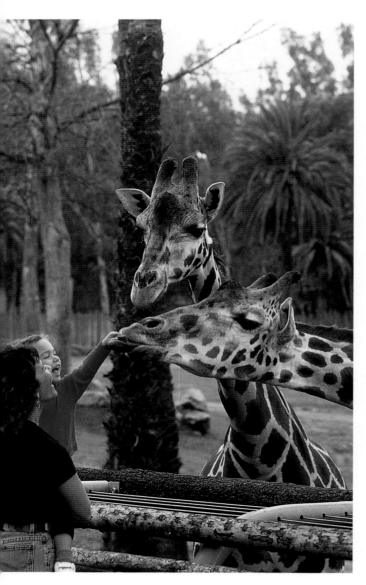

The San Diego Zoo and Wild Animal Park are widely recognized as among the nation's premier animal and conservation facilities. More than five million people visit the Zoological Society of San Diego's two facilities each year. More than one million of them are children. In passing on their message of conservation, education, reproduction of endangered species, and the protection of habitats, the organization begins speaking with young customers early through exhibits, programs, and targeted designs, including *Sydney's Koala Club News* and Kid Territory. The newsletter is published six times per year expressly for approximately 140,000 young readers. Kid Territory is a part of the zoo's Web site created exclusively for children. Both are fun, informative, and powerful in their message. Newsletter editor Karen Worley and Web site manager Inigo Figuracion share how they make the sale.

Inigo: For children, you really need to think outside the box. Usually, you're thinking of what you like as an adult. Adults might like a bit of flash or extra information: With kids, you have to be more to the point with design and content. Be more straightforward than clever. Yes, you can make it fun. But in our case in particular, the underlying goal is serious: understanding wildlife and what we can do to help it.

Karen: Considering our subject matter, it's not hard to grab a child's attention. Basically, we are selling the concept of animals. If we have a cute or interesting animal on the cover of the newsletter, kids will look at it.

But you still have to be careful: Kids know when they are being sold to, and I think they are tired of it. Our publication doesn't have that tone, even though we are selling a message: We actually give them something that they want. I think children enjoy that.

Building Involvement

Inigo: All of our graphics are built from a thread of design from the zoo itself, whether it's from signage or advertising. That's where we start. But with the Web site, we tend to be a bit more bold. Our colors are more eye-catching, and we do use primary colors. We keep it simple. I do find, in other sites and in working with outside designers, that you do need to rein it in sometimes. You can't get too wild. In a general sense, kids do seem to be drawn to splashiness. But we have to consider that we are doing design in the context of our message, so we have to scale the graphics so they don't infringe on that message. A purely entertainment site is a candy site—that's pure sugar. We have to balance that with some goodness, too.

Karen: The newsletter has the same situation. We are competing against four-color publications that are similar in subject matter. Right now, we're a three-color newsletter. We've considered going to four colors, but at this time, I don't really think it's necessary. We're going for visually dynamic—visually stimulate the kids so they want to dig into the newsletter right away.

We use a coated matte or velvet paper for a quality look and feel. High gloss is not appropriate for our young readers because reflections on the paper may make it difficult for them to read. We definitely don't want to distract from their experience.

Inigo: The key is to involve the children right away, whether it's the newsletter or the Web site. Of course, we have lots of games that I think are a really good use of Flash animation. You can build a crazy animal out of different animal parts, or drive a truck over a shaky bridge while transporting animals. Even though these are fun to do, the message stays pretty clear. We teach children about how much money can be spent in a conservation project, or how the body parts of an animal have evolved over the years, but they are still playing.

opposite: Children and animals make a natural combination for newsletter and Web designers at the San Diego Zoo and Wild Animal Park.

left: *Sydney's Koala Club News* is a six-page bimonthly newsletter published by the Zoological Society of San Diego. It is exclusively for members of the Koala Club, whose ages range from 3 to 15. The three-color publication keeps children up to date with San Diego Zoo and Wild Animal Park events; more important, it delivers information that enables them to help the environment.

above left: Kid Territory, part of the Wild Ideas area on the Web site of the San Diego Zoo, is full of fun for kids—art projects, science experiments, silly facts, zoo news, and more—and also designed to help children learn more about preserving the world around them.

above: The fold-out pages of the newsletter are packed with art, type, and color. "We try to maintain density throughout the entire publication," explains editor Karen Worley. Shapes, abstract textures, lines, and bits of clip art add to the visual interest. Worley and her design team look for color combinations that include a bright hue like yellow or orange, a fairly dark color like purple for type and halftone elements, and a third color that can be more symbolic—blue for water or green for plants, for instance.

Karen: We also have games and puzzles, but these are usually targeted to the younger audience members. The stories are a bit more sophisticated and require more reading, so those are for the older children. We try to provide something for every reader.

We definitely do have a lot of cute stuff as well as cartoony art. I go for humor and silliness whenever it is appropriate. We also go for gross, such as what kinds of disgusting meals the animals eat or how the horned lizard can shoot blood out of his eyes as a defense. But when we have an article on something that might be a bit scarier, like on venomous snakes, we don't want to scare the reader off. So we might use fun art instead of a photo and give the child information on how to be safe around such animals.

We also don't want to frighten off young readers with an overwhelming amount to read, so we limit articles to about eight hundred words. Writers have to stick to the most compelling details. And we use tons of typefaces for headings; I'd estimate that we use one or two new ones each issue. It keeps the publication new and fresh.

"I like animal web sites the best so I can get pictures of lions and tigers to color." Kenny, age 6



above right: A message of conservation and preservation is a natural one for children. A cute animal on the cover is nearly infallible, says editor Worley. Small people usually like other small creatures.

above and right: Crafts and games are included mainly for younger children, while longer articles are of more interest to older kids. By including different levels of activities without alienating any particular age group, the newsletter can serve a wide age range.

Inigo: For text, we keep content in bite-size pieces—not to diminish the content, but for organization.

Interactivity is the big thing for us, but this can have several meanings. You can send virtual post-cards or play games, or you can be involved with a more traditional form of interactivity: In the Kid Art on the Refrigerator Door section, kids can send us their own drawings, which we might put up on our virtual fridge on the Web site.

How Kids Learn

Karen: It goes back to creating opportunities for the child to be involved. Involvement creates a sense of belonging, of ownership, so kids really care about wildlife and what the zoo is trying to do. And we always, always talk to kids like regular people, not talk down to them, and we keep things as positive as possible for them. There is a lot of negative information out there, on things like how fast the rain forests are being destroyed. We want them to know that it's not too late for them to be active and make a difference.

right: The zoo's Web site has plenty of crafts and art projects that children can complete with items they find in nature or in their at-home recycling bin. Each project puts the child in touch with nature.

below: Jungle Bridge is a more involved game that confronts children with practical issues of conservation. They learn about the costs involved with protecting endangered species. The goal is to save as many animals as possible without running out of cash or breaking the bridge.

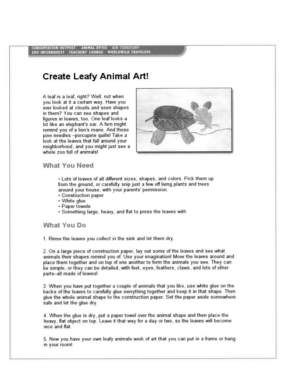

Create Leafy Animal Art!

A leaf is a leaf, right? Well, not when you look at it a certain way. Have you ever looked at clouds and seen shapes in them? You can see shapes and figures in leaves, too. One leaf looks a lot like an elephant's ear. A fern might remind you of a lion's mane. And those pine needles –porcupine quills! Take a look at the leaves that fall around your neighborhood, and you might just see a whole zoo full of animals!

What You Need

- Lots of leaves of all different sizes, shapes, and colors. Pick them up from the ground, or carefully snip just a few off living plants and trees around your house, with your parents' permission.
- Construction paper
- White glue
- Paper towels
- Something large, heavy, and flat to press the leaves with

What You Do

1. Rinse the leaves you collect in the sink and let them dry.

2. On a large piece of construction paper, lay out some of the leaves and see what animals their shapes remind you of. Use your imagination! Move the leaves around and place them together and on top of one another to form the animals you see. They can be simple, or they can be detailed, with feet, eyes, feathers, claws, and lots of other parts–all made of leaves!

3. When you have put together a couple of animals that you like, use white glue on the backs of the leaves to carefully glue everything together and keep it in that shape. Then glue the whole animal shape to the construction paper. Set the paper aside somewhere safe and let the glue dry.

4. When the glue is dry, put a paper towel over the animal shape and then place the heavy, flat object on top. Leave it that way for a day or two, so the leaves will become nice and flat.

5. Now you have your own leafy animals work of art that you can put in a frame or hang in your room!

"I liked the St. Louis Zoo because I went with my parents and there was lots LOTS of things to do." Gracie, age 11

I used to be a high school teacher, and I learned that there are different types of learners. Some people are visual learners; they learn by seeing. Some are auditory learners; they learn by hearing. Then there are kinesthetic learners; they learn through movement. My philosophy is to keep the child doing something. Kinesthetic learning is a combination of these learning techniques. It uses all parts of the brain, and it's more fun, too. Whether the child is doing a puzzle or looking at the Web site moving a mouse around, he is actively involved.

left: Build-a-Beast is an especially enjoyable interactive game. At the same time children build the weirdest animals they can dream up, they are learning about how particular animal parts make animals specially suited for different areas of the world.

below: Recipes for healthy snacks, each with silly animal names, are full of puns. Pictures are included.

Head/Neck ✓Savannah Woodlands Forelegs

Ears/Horns Hindquarters

Torso Tail

Click on each of the animal parts to build your beast. Choose from more parts by scrolling with the arrow buttons. You may change the habitat, "Savannah" or "Woodlands", at any time.

Build A New Beast

Jaguar

powerful, large cat that prefers to e alone, the jaguar keeps other cats ut of its territory by leaving scent narks that mean "No Trespassing!"

CONSERVATION OUTPOST ANIMAL BYTES KID TERRITORY
ZOO INTERNQUEST TEACHERS' LOUNGE WORLDWILD TRAVELERS

**Dandy Duck Dip
Served With Quackers**

Ducks come in as many sizes, shapes, and colors as crackers do, so let's get "quacking" and create a dandy duck snack sure to fit the bill. This recipe is quick, easy, and fun to mash!

Ingredients:

- 1 large banana
- 1 Tablespoon honey
- 1 Tablespoon peanut butter–creamy is the easiest to spread
- crackers–your favorites (Ritz, Triscuits, or Goldfish, a duck favorite!)

Peel the banana and put it in a small bowl. Add the honey and peanut butter and, using the back side of a spoon, mash the ingredients together until they make a creamy soup. Serve with crackers for dipping!

Dandy duck dip is sure to bring a migration of friends to the table!

wild ideas home
conservation outpost | animal bytes | kid territory | zoo internquest | teachers lounge | worldwild travelers | calendar

Kid Art on the Refrigerator Door
Send us your creations!

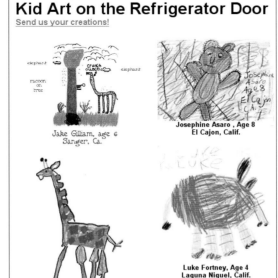

Jake Gilliam, age 6
Sanger, Ca.

Josephine Asaro , Age 8
El Cajon, Calif.

Luke Fortney, Age 4
Laguna Niguel, Calif.

Elisa Brittain, Age 5
Phoenix, Ariz.

left: Here's a different sort of interactivity: Children send their animal art projects to the Web site for possible posting.

Ringling Brothers and Barnum & Bailey Circus

How do you redesign an icon? When Ringling Brothers and Barnum & Bailey® Circus management decided it needed to make its image more relevant to today's kids, it tapped Big Blue Dot for the task. Long considered an authority in design for children, Big Blue Dot cleverly found ways to build on the equity of the circus's long-standing identity while creating new appeal for the brand. Creative director Scott Nash and art director and lead designer Bob Troutman explain how their design team reintroduced The Greatest Show On Earth®.

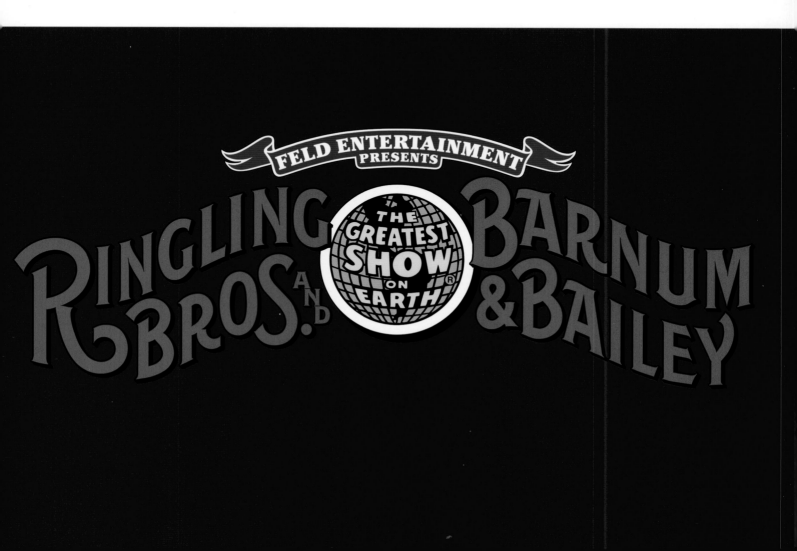

Scott: There was a time in American history when the two biggest days of the year for a child were Christmas and circus day. The day the circus came to town was a huge event. But now we've gotten to the point where, with television and other forms of media, live performances are not as well attended, and certainly not the circus. A family's time for a live event was being usurped by spin-offs of TV shows—Elmo Live and Disney on Ice, for example.

Having gone to the circus when I was a kid, these were experiences I would never want to lose. The trick for Ringling Bros. was to make the circus more relevant to today's kids and families.

When we were first called in for a presentation, I was certain we did not get the project because we asked pointed questions. How was Ringling handling animal rights issues? Weren't quotes like "A sucker is born every minute" attributed to Mr. Barnum? Is the circus really "The Greatest Show On Earth," or have events like the Super Bowl taken its place?

Ultimately, we were picked to do the positioning. We had a twofold strategy. The first goal was to find a way to make kids think about Ringling Bros. all year long, not just as a one-time event. The other goal was to change people's habits concerning the circus. We found through research that parents did actually want to take their kids to the circus, but if they missed it, they could always go next year. They didn't think they would miss anything.

Images courtesy of RINGLING BROS. AND BARNUM & BAILEY® THE GREATEST SHOW ON EARTH®.

Reconnecting with Kids

Bob: So our message definitely had to have crossover appeal for kids and adults, although it was clear that the circus's traditional look was not connecting to kids today. In fact, the circus's identity was a strange mix of photography and illustration that was really struggling to find its own voice.

As far as a graphic convention for collateral, the circus didn't really own one. So we researched to find out exactly what people today would recognize about the circus. Parents and other adults felt that the circus is wholesome fun, that it is a live show, that it is always a surprise, that it is a spectacular event, and it is an all-American tradition. Kids 8 to 12 years old believed it has the greatest athletes in the world, that it has the thrill of danger, and, like adults, that it is a spectacular event. Finally, kids ages 3 to 7 years old felt they would see amazing animals at the circus, that they would have a cozy time with their parents, and that they would enjoy lots of special circus treats.

Scott: The circus goes to great pains to create a new show every year. Every year, Ringling travels the world to find new acts. Each year brings a totally different show.

To create a greater sense of urgency and establish a year-round presence, it seemed natural to bring back the fine tradition of the circus poster. We wanted to really push the concept and use a different illustrator for the poster at each new edition of the circus. The poster, then, would help drive all of the other visual elements for the circus for that year.

above and below: Big Blue Dot designers decided to retain the seal element of the original mark, reworking the typography so it encircles the globe. Canting the globe slightly emphasizes the view of the earth spinning on its axis. These versions show different colorations.

opposite: Ringling Bros. and Barnum & Bailey Circus's original logo is familiar to most Americans—so familiar, in fact, that it is actually an icon.

right and opposite: Paired with the new globe seal is the art of Chris Van Dusen, the first in a projected series of well-known children's illustrators who will annually recreate the art and typography of the circus. Ringling Bros. offers a brand-new show every year, so every year it will have a new complementary look. From left are the envelope, stationery, a mailer, and a mailing label.

Bob: In order to speak to kids and adults, we decided to go with the art of illustrators who are famous primarily in the children's book arena but not necessarily limited to it. We started with the art of Chris Van Dusen. He has a certain kind of energy and has such a command of line, shape, and forced perspective. His work also has a cartoon touch to it, which works well. He also hand-lettered an entire playful alphabet that is different from the old font styles the circus used before. I'm not saying that kids are automatically attracted to kooky type, but the shapes and colors we used were chosen to attract a kid's eye. Next year, we will do something completely different, stylewise.

A Completely New Look

Scott: This was a big step in many ways. Ringling Bros. established the way all circuses look: heavy filigree, heavily outlined letters, and such. But we found that consumers thought of that as generic circus. So even though they invented the look, we suggested that they abandon those clichés. We also concluded that the greatest equity for Ringling Bros. lies in the tag line "The Greatest Show On Earth." So we reduced their old logo to just the element that would be their constant—the circular seal. But every year now, the circus's typography will change. The art will change. The style of the art will change. It all speaks of a fresh show every year.

Images courtesy of RINGLING BROS. AND BARNUM & BAILEY® THE GREATEST SHOW ON EARTH®.

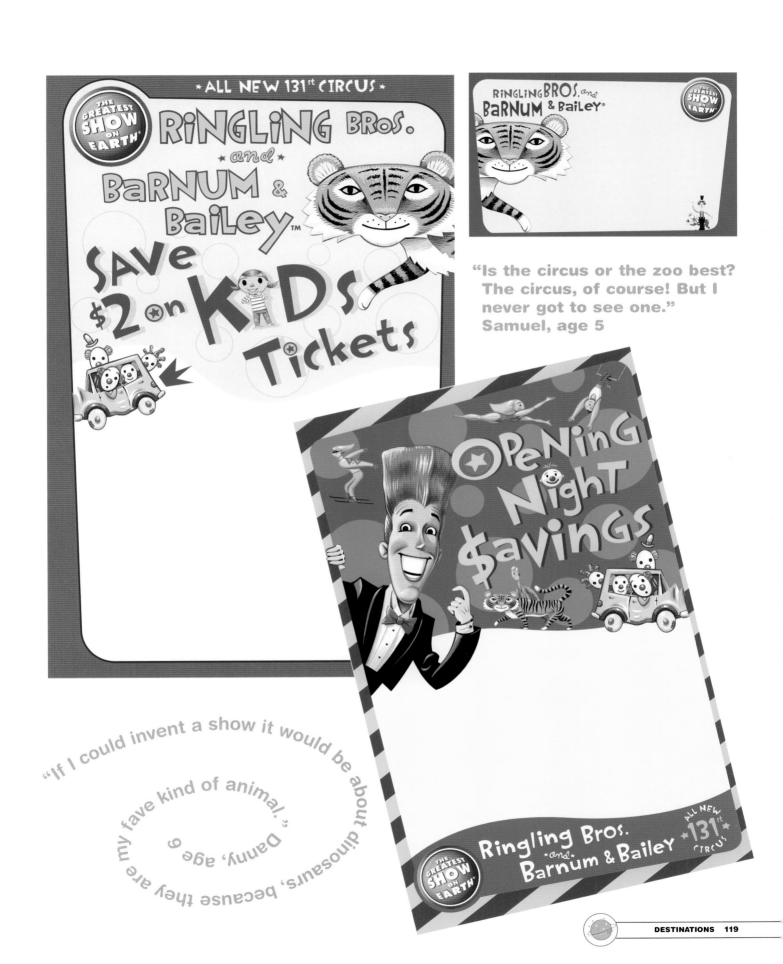

"Is the circus or the zoo best? The circus, of course! But I never got to see one."
Samuel, age 5

"If I could invent a show it would be about dinosaurs, because they are my fave kind of animal." Danny, age 6

right and opposite: The tradition of the large and exciting circus poster serves as a natural showcase for each new year's art. To show Feld Entertainment, the circus's owner, how much the style could change from year to year, Big Blue Dot designers comped up these trial posters.

"I like to see the animals and seals especially."
Kayla, age 7

Bob: For the seal, we kept only the "Greatest Show On Earth" globe and reworked the typography around it in a circular path. The round shape of this logo, or seal, is much easier to design with and, visually, is easier to identify with than what they had before. When we first started designing the logo, we kept the type vertical, centered on the y-axis. But something was lacking visually, so we rotated the type slightly, based on the tilt of the Earth. As soon as we did, we realized that it really gave it some torque and brought much more energy and a contemporary feel to the identity.

Scott: We kept referring back to Barnum; he was too good a marketer to abandon his thoughts. He said, "Never before seen and never seen again." That's what we want children to feel—that they have only one chance to see this show.

This is a form of theater that many Americans love. I think its message has been made clearer and more contemporary for parents and children. We're not creating the feeling that you are going back in time to a historical circus but rather that you will be transformed somehow by what is still really an extravaganza.

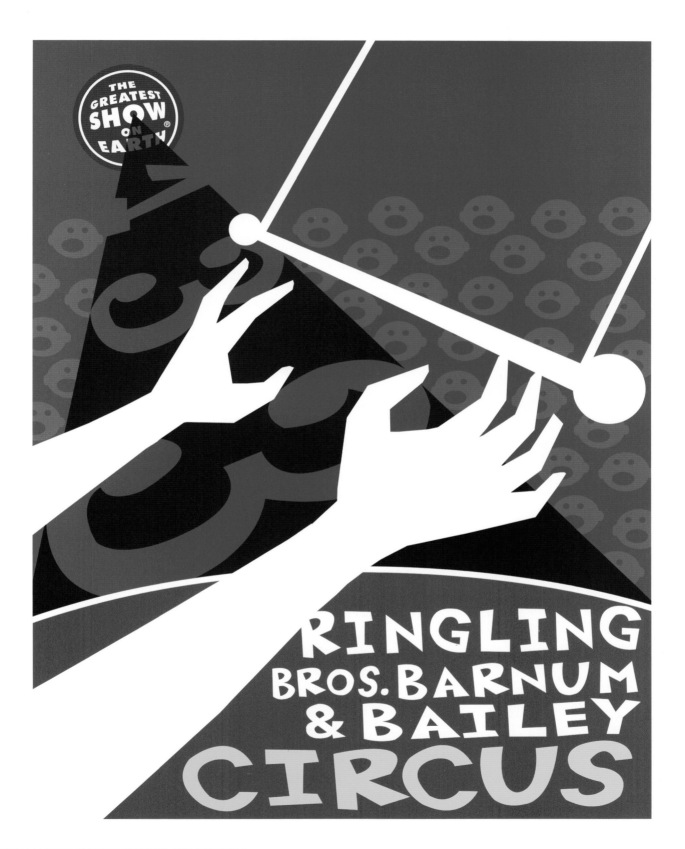

Kids' Studio

The ultimate experts on what kids like best are kids themselves. That's architect Alla Kazovsky's mantra when she is designing the ultimate children's destination, the private bedroom. Just ask, and they'll tell you not only what they want but also what they really need in order to learn and grow. Many of her design ideas spring from drawings that children create for her, detailing their perfect rooms if the sky—and sometimes not even that—were the limit. Kazovsky, principal of Kids' Studio, a Los Angeles–based architecture and education firm that specializes in creating enriching environments for children, translates those wishes into practical, but imaginative, room and furniture designs.

below: This car-as-desk would be a fabulous element in any child's room, especially a young person enamoured with vehicles. It is such an imaginative piece, in fact, that the rest of the room could be quite common, but the space would still be wonderful.

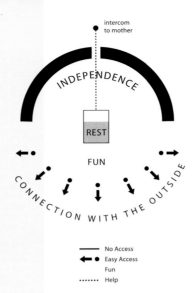

intercom
to mother

INDEPENDENCE

REST

FUN

CONNECTION WITH THE OUTSIDE

—— No Access
◄● Easy Access
Fun
······· Help

They Want Autonomy

Alla: I'm committed to the developmental aspects of designing for children. I conduct workshops to investigate their point of view. Letting children design a room of their own, allowing them to think about the space around them and how it can reflect their special personalities is important. I let them design an imaginary room that is perfect for them. After I look at enough of these, universal truths begin to emerge. Most kids want similar things in their ideal world.

First, children want autonomy in their own space. They will ask for a button to a secret entrance or post a sign that reads "Clubhouse for Members Only." Second, they want a connection with the outside world—in particular, nature: "I want a chair that takes me to another country," or "My bedroom is like being outside." Third, they want safety. Maybe they want an intercom with which they can call their mother or ask for a platform from which they can jump onto something soft.

The one piece of furniture that is present in every single drawing is a bed. It is so important, that place for resting. The remainder of the space is always for play, fun, and for their favorite possessions and pets.

Autonomy is crucial. Children often want to control access to their space. As they get older, privacy becomes an issue. They will often draw an entry as a very small door or tunnel that grown-ups would have a hard time getting through. In reality, it probably wouldn't be practical to make a door smaller than a standard size. However, you could put curtains over the door or let them have a "No Adults Allowed" sign prominently displayed on the door.

Autonomy also means letting the child have control of the space. In one room I worked on, locating a study area in the corner seemed like the best use of space, but that also meant that the girl using the desk would not be facing a balcony with a beautiful view. So I designed a built-in unit complete with bookshelf, computer station, and pin-up surface, plus a pivoting work surface. The girl who lives there can position the oval pivoting table so that it faces the wall or her balcony window. In another room, I put a boy's bed on wheels. If he has friends over and needs more space to play, the bed can be pushed into a corner. As he gets older, too, the wheels give him the power to redesign the room the way he likes it. Keep in mind that movable pieces need to be lightweight. It's also nice if they can have more than a single use, such as drawers that pull out to make independent storage boxes.

Children also need plenty of space to display their treasures and artwork. When their possessions are organized into neat categories and everything is in its place, not only is the room easier to clean up, but also they have an easier time deciding what they want to play with at any given time. The particular way that everything is displayed becomes another opportunity for children to customize their own space. Easy access is critical.

above left: This diagram details the structure of a child's ideal room, according to Alla Kazovsky, principal of Kids' Studio, a Los Angeles–based architecture and interior design firm that specializes in the design of children's rooms. The bed is the most sacred and private place, at the center of it all. Inside such a space, the child has autonomy and privacy, a connection with the outside world, plus safety through connections to caregivers.

above: This athletic-field bedroom clearly shows a desire to be outside. Tracks lead to a sports arena, a pool, and a racquet court. For this child designer, Kazovsky would use muted green, low-pile, wall-to-wall carpet to suggest grass. Placing the bed on casters would allow it to be easily wheeled out of the way to provide maximum space for exercise and movement. More musts: Plenty of shelves to display trophies and sports memorabilia, and bins on casters to hold sports equipment.

right: This drawing was done by a fifth-grade girl who clearly is into self-expression. Kazovsky would encourage allowing her to do plenty of the design work herself. First, the stage could be set with neutral-toned furniture that serves as a subtle architecture for the room. Then the child could add her own touches: a custom-painted floor, a wall designed expressly to display her own artwork, a self-designed bedspread and headboard, and, if possible, a skylight to give her a symbolic and useful connection to the world.

"I always ask my mom and dad for a TV in my room, and they always say no. I bet if I got a TV my grades would drop a lot, so in a way, their answer is OK." Lindsay, age 11

They Want Security

But even though children want privacy and autonomy, they also need security. That's where they ask for an intercom to mom or a mechanical helper; they want to be able to get help right away if they need it.

The kids long to have a connection with the outside world. Sometimes they imagine their room as an underwater vessel that has aquariumlike windows all around, even in the floor. Some children might envision a cloud bed in the sky or a tunnel to China or even a bedroom right on the beach. Placing a bed in the curve of a bay window could be a way to address this universal longing to be one with nature. A painting of the beach or of outer space, maybe even done by the child, is another way to make a connection.

I think it's important, too, to consider children's scale. Some drawings include a ladder to an upper level or just a bunk bed. My interpretation is that kids are just much smaller than adults. They perceive an opportunity for vertical movement within their space. For them, there is plenty of room for another level. Their sense of design does not come with the same baggage and expectations that we as adults have developed.

above: Children frequently draw bedrooms that are underwater, with portholes or aquarium-like windows. To accommodate this wish, Kazovsky might paint designs depicting sea creatures on a large piece of canvas that could hang on the wall but be removed easily when necessary. A changeable, wall-size map provides another springboard for the child's imagination. A ladder bolted to the wall gives the child a second layer of space in his room; track lighting can be arranged to suggest darker and lighter areas, like light dappling through water.

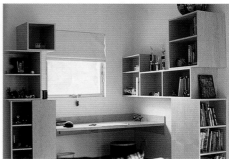

above: Children's rooms should provide plenty of space for personalization with their own treasures. The designer creates the space, and the child completes the design.

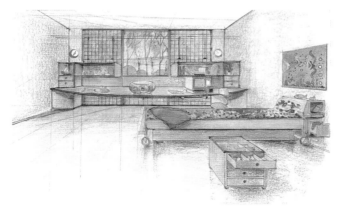

left: This sketch shows a possible design solution for a child who dreams of an underwater room. Watery colors and an open, airy space provide lots of swimming room; hanging art and sheets can furnish actual aquatic graphics. An actual fishbowl or aquarium gives the child a touch of the real thing. Note how the only furniture in the room is on casters, allowing the child to clear the floor and customize the room as he wishes.

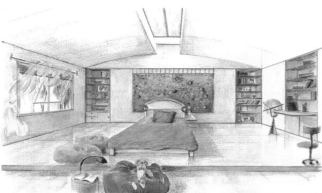

above: This room was created for a child who wanted a room in the clouds, another common request. An airy, well-lighted space is a must, of course, as are sky-appropriate colors and art. But in this space, a skylight and a raised platform for the bed offers the child a real, physical lift into space.

below: Building the bed—a child's most precious, private space—into a windowed bay gives the child an almost physical connection to the outside world, a sensation children crave.

Whether you are designing a room or a toy or whatever, the design needs to be respectful of the fact that children are always changing and growing; the design has to grow with them. A single theme, no matter how exciting and appropriate at the moment, is going to get old. The idea is to invent something that will be transformable somehow, ideally at the child's hands. The furniture should have neutral colors and be a subtle backdrop around which children can build their own world. Color accents can be added with things like bedding that are easier to change over time.

A design that overpowers children's feelings won't work. Children have sophisticated taste and ideas; the best results can be achieved when they are listened to.

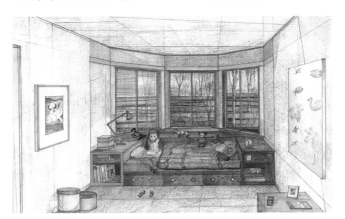

"I like brown because I have brown eyes." Josey, age 9

above: Many children crave a connection to the outside world for their bedroom, as this child's drawing of a bedroom on the beach clearly shows. As a designer, Kazovsky says she would meet this child's dream bedroom with practical answers. Large windows provide natural light and ventilation, while a large circular throw rug on the floor provides a soft play area, like warm sand. A colorful floral bedspread might suggest a tropical theme, and a kite decorated by the young resident could be hung from the ceiling as a visual cue of beachside activity.

right and opposite: Kazovsky also creates custom-designed furniture for children's rooms. Furniture, she says, should serve as a subtle architecture for what the child wishes to do with the space.

"My favorite color is green because it remembers me of my favorite shirt." Tyler, age 8

8 & 9
AGE CUES, DESIGN CLUES

year olds

Age Cues—Design Clues for 8 to 9 year olds

With more and more math in their scholastic diets, eight- and nine-year-olds are budding spatial thinkers. They can bring enough of their own information to a design to permit a complex interactive experience. This age group also is beginning to develop a cultural vocabulary that allows them, among many other things, to have a sense of humor and a wonderful appreciation of absurdity. Knowing what is "right" lets them enjoy things that are "wrong." Design for this age can take more risks. These children, although they are still small, aspire to be at least three or four years older.

MOTOR AND PHYSICAL DEVELOPMENT
Small hand muscles are developing. • Arts and crafts are popular.
• Games with small pieces or buttons are feasible.
Although these children are active, they still need rest times. • Designs that can be appreciated alone or quietly fit well into their lives.
Have definite preferences for favorite activities. • Designs that relate to favorite activities—a backpack or shirt with skateboarding graphics, for example—are welcome.
• Create graphics that can be applied to accessories of favorite activities.
Children this age may become sedentary without intervention. • Activities might include methods of keeping track of progress.

SOCIAL SKILLS
Are good team players; can follow rules and take turns without adult intervention.
• Graphics that identify the user/wearer as part of a team will work. • Games or activities that permit team play will work.
Can be daredevils; start to enjoy some degree of risk. • Designs should not encourage risky behavior, but can take chances through more extreme colors or graphics.
Respect other people's space and property; like to have the same respect from others.
• Graphics that personalize belongings are popular. • Create customizable designs—with color and pattern, for instance.
Recognize others' emotions and can react appropriately. • Designs can include more emotion and abstract reasoning. • Illustration, in particular, can depend on the young reader to complete the picture.
Very interested in friendship. • Pairing activities are popular. • Designs that allow children to communicate with each other will work. • Designs that identify the user/wearer as part of a larger group will work.
A more thorough sense of humor develops. • Can appreciate designs that satire or mimic other cultural references. • Any activity that involves jokes and riddles is popular.
• Designs can include more absurdity.

INTELLECTUAL AND COGNITIVE DEVELOPMENT
Are becoming better readers. • Simple instructions and longer blocks of text are tolerated. • Still include plenty of pictures with text.
Are experimenting with different shades of specific colors. • Designs can show depth using color. • Activities can include drawing with details—exploded view of model, for instance. **Can read books with chapters. Are able to pinpoint main idea.** • Stores or games may be longer, with more detailed plots and appropriate endings.
Developing more sophisticated concepts of addition and subtraction. Can count in new ways (by fives, tens, and so on). • Activities can include higher levels of mental manipulation of space, degrees, and quantities. • Working with time and money becomes easier. • Designs can involve being timed.
Understand more about the natural world and what makes it work. • Art can include greater degrees of shading and atmosphere. Example: clouds rather than raindrops to indicate stormy weather. • Graphics that include more elements from the natural world are popular (lightning, leaves, and so on).
Understand jokes and riddles. • Use humor in graphics

CONSUMABLES

If we are what we eat, some grown-ups might suspect that children are blue raspberry super-gummy candies. But children are actually smart about what they will eat, especially when they are spending their own money. That makes designing food products and other consumables that stand out especially difficult.

This section contains four success stories. Each brand or project relies heavily on design of packaging or product.

Cheerios: This powerhouse brand continues to grow and grow, using design to appeal to new age groups.

Sonic Wacky Packs: Child-design specialists C3 don't see a kid's meal toy as junk. In fact, it's an opportunity for learning and inventive play.

Bubble Tape: Gum is gum is gum, right? Not for Amurol Confections, inventors of Bubble Tape, Big League Chew, and other innovative products.

Milk Chugs: Sales of milk were seriously declining, so Dean Foods found a way to make it cool again.

Cheerios

Since its introduction in 1941, Cheerios has become one of the most recognized and trusted family brands in America. The popularity of Cheerios spans across many age groups. Over the years, General Mills has expanded the Cheerios franchise by launching new varieties targeted to specific consumers. Each brand in the franchise reflects the same nurturing, wholesome values as original Cheerios. Other than taste, one of the biggest factors in separating one brand from another is packaging design. Beth Rampelberg, senior design coordinator in charge of Cheerios, and Liv Lane, spokesperson for the Cheerios franchise, explain how design has helped the Cheerios brand appeal to new age segments.

Beth: Before you start designing a cereal box, you must understand the brand and its core consumer.

Liv: Cheerios has always been about nurturing and providing wholesome goodness to the consumer. All of the brands in the franchise must reflect those core values in everything from the advertising to the packaging.

Beth: That's always in the back of my mind when designing packaging for any brand in the Cheerios franchise. Those values are our framework. Building on that, each brand has its own personality that appeals to a specific consumer.

Liv: The challenge is not only to get people to buy the product but also to keep the packaging design fun and interesting for them when the box is on the breakfast table at home. After all, over half of consumers read the same cereal box more than once. That's why Beth's team works so hard to make sure the target consumer can relate well to the packaging.

left: Kids everywhere recognize the big yellow box as Cheerios, the first solid food many children enjoy. General Mills has extended the brand over the years to keep all ages of consumers happy. The package design also reflects the lifestyles and language preferences of consumer segments around the world.

Segmenting through Design

Beth: Exactly. Frosted Cheerios is targeted toward tweens. That age group is at the stage in life where they are pushing away from childish things and struggling to become independent adults. Frosted Cheerios is a perfect fit for 10- to 13-year-olds. It's fun and edgy, but still has the familiarity and safety of Cheerios. On the back panel, we try to have fun games and information that both empowers and entertains this age group, such as How to Be a Yo-Yo Pro.

Liv: And then you have to totally shift gears to appeal to the target of another brand, like Apple Cinnamon Cheerios.

Beth: Yes. Apple Cinnamon Cheerios is a unique challenge because we're targeting moms with kids ages three to eight. We are designing packages that gatekeepers think their kids will like. We try to include games and activities that are interesting to the kids and, at the same time, we're reinforcing the wholesome goodness of Cheerios to moms.

Liv: And then there's Honey Nut Cheerios, which has BuzzBee—the only equity character in the Cheerios franchise.

Beth: BuzzBee is the star of Honey Nut Cheerios. He's been featured on the box since the brand launched in 1979, but we hadn't done much with him until recently. In 1999, he received a makeover. That included giving him new antennae and sneakers and a rounder, friendlier face. The goals were to make him look less like an insect and make him more contemporary and appealing to the core consumer: the entire family, with a focus on 9 to 12 year olds.

above left: Honey Nut Cheerios are for the 9 to 12 year old group as well as for the entire family. BuzzBee is beginning to be shown doing things children this age would also do. In addition, General Mills designers plan to delve into his personality as a source for more graphics.

above right: The electric blue Frosted Cheerios box and its contents are targeted to the 10 to 13 year old set. Teens and tweens like designs that are a bit exciting. They associate pastel colors with younger children, and, of course, they want to be more adult.

right: The MultiGrain Cheerios box was obviously designed for the more adult audience, with its references to health and good taste.

far right: The design of the Apple Cinnamon Cheerios box is targeted to prekindergartners whose mothers are still gatekeepers for what they eat. Its packaging has a gated backyard design, indicating that this is a safe place to be. Colors are primary and bright, and the shapes and textures on the box are soft and rounded.

right: Team Cheerios has an obvious patriotic appeal. Red, white, blue, and gold bring forth thoughts of sports and winning.

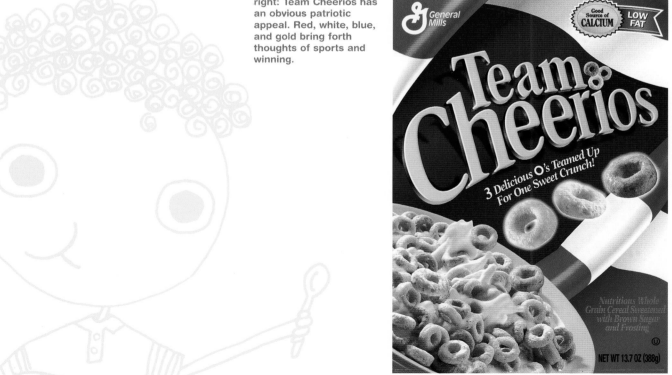

Liv: Then, in 2000, he finally got a name. We launched a national kid contest to name the Honey Nut Cheerios bee and the winning entry was BuzzBee. I think my all-time favorite package was the Honey Nut Cheerios box that Beth and her team designed to celebrate the announcement of BuzzBee's name. They did a great job, dressing him in a tuxedo and seamlessly incorporating a photo on the back panel of the girl who won the contest. It was adorable.

Beth: Now that we've further developed BuzzBee's personality and updated his looks, we've really got more opportunities to leverage the character on the box. There's potential for BuzzBee comic strips, in-pack premiums, games, and more.

Liv: And the key there is to make everything we do with BuzzBee age appropriate. Making him appeal to older kids means he needs to take part in things that are cool in that age group, from telling jokes to snowboarding.

Keeping Pace with Your Consumers

Beth: It's hard to keep up with what's hot among kids, as trends change so often. But that's part of staying in touch with your target. There are a lot of ways to do that. General Mills has an internal team of kid experts with a Web site, newsletter, and more. They always know what other companies are doing and what's popular with kids, from music to fashion to eating habits. The team is a great resource.

"I've noticed that they don't put toys in cereal as much anymore, but I like those toys." TJ, age 12

above: The design of the front and back panels of each cereal variety box are entirely devoted to their designated age group. For instance, Apple Cinnamon Cheerios is targeted to smaller children and their caregivers, so the back panel of its box is covered with activities for the younger set.

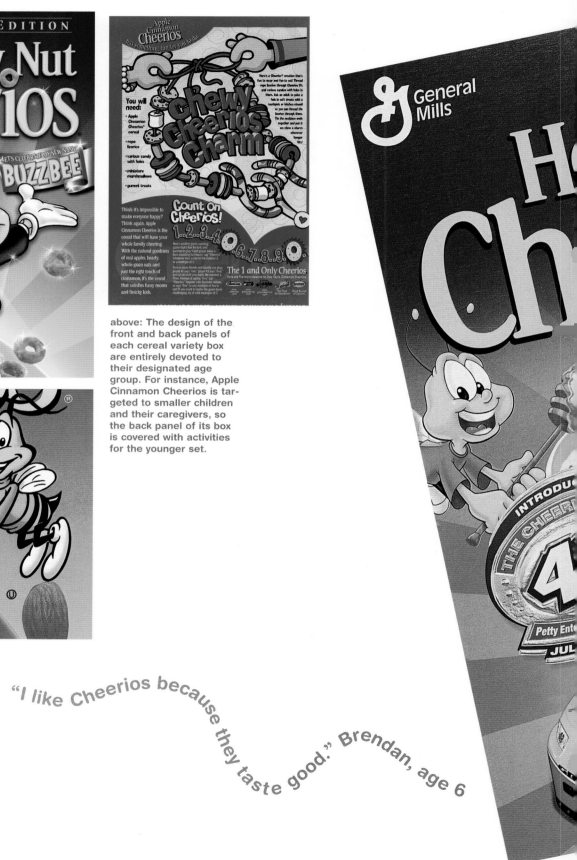

above: With kids' cereals, character equity is an important element. BuzzBee has graced the Honey Nut Cheerios box since 1979 (bottom). In 1999, however, he enjoyed a makeover that made him a character who could go skateboarding, tell jokes, play sports, or anything else a child of 9 to 12 might do (top).

"I like Cheerios because they taste good." Brendan, age 6

left: In order to grab the attention of busy shoppers, devices like holograms are sometimes included in front panel designs.

"I think we're healthier than twenty years ago. Kids 20 years ago ate a lot of junk food." Max, age 10

Liv: Many brand teams also host ideation days to come up with new ideas and to stay in tune with kid trends. For instance, the Frosted Cheerios team had a tween immersion day. We spent the day at the Mall of America, observing tweens and paying attention to what they were buying, what they were eating, who they were hanging out with. We also watched a lot of popular tween shows and advertisements and ate tons of junk food. In addition to understanding current tween trends, we all reminisced about what it was like to be in junior high. It was such an awkward, challenging time, and it still is for that age group.

Beth: Yeah, it's important to understand children's developmental stages and try to remember what it feels like to be at those stages. You have to surround yourself with what kids do. Watch the Cartoon Network. Read *Nickelodeon* magazine. Check out popular kid Web sites.

Liv: And, in addition to all of that, try to find opportunities to actually spend time with kids. Offer to take care of your friends' children, volunteer at a community center or school, invite kids in to shadow you at work. If you have kids of your own, don't let them be your only measurement tool. It's easy to base your judgment on what your own children like and don't like, but there's a whole world of young people out there with a broad spectrum of opinions. I'd definitely recommend spending time with kids in the age range your brand is targeting.

Beth: The more you understand your target, the better your designs will be.

Sonic Wacky Packs

Of all the design groups featured in this book, the C3 staff might be envied for having—in the words of a small child—the "funnest" jobs. Every effort of the fifty-person firm is directed toward promoting its clients' brands to children and their families, so C3 designers immerse themselves in kid culture, studying everything from toys and food to literature and Web sites. Creative director Phil Reynolds, art director Dave Swearingen, and senior designer/illustrator Amy Frisch explain here how they put their team's efforts into a children's meal program for Sonic, a leading national quick-service restaurant chain.

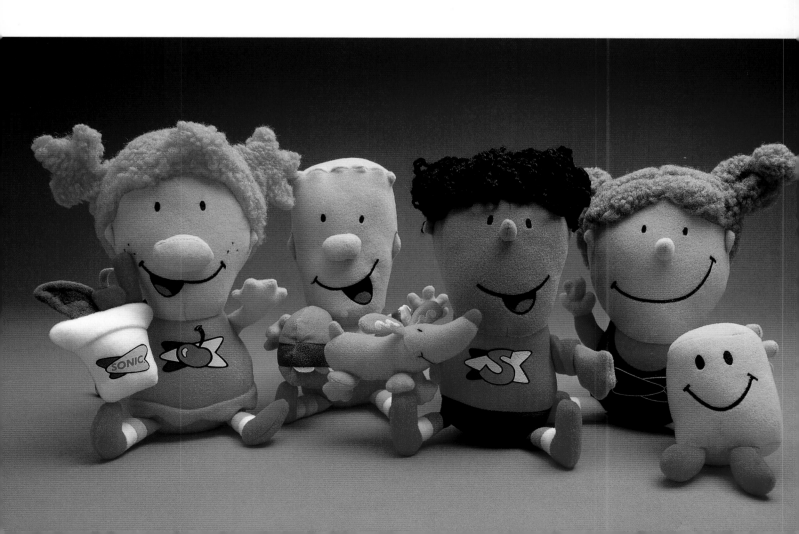

Sonic Boom

Dave: There are twelve people on the Sonic project, including three full-time artists. When we're developing a new premium, we take a week and send everyone out to buy toys, look at kids' games, check out Web sites, watch kids to see what is really cool right now. Then we come into our Brainwave Bar—the conference room—and set all of these things on the table and play with them. What can be adapted for what our client's needs? What has the right level of playfulness, parent friendliness, and education?

Amy: Sonic wants something that is educational. Sonic really wants to associate with children in a good way. A lot of the company's competition goes for licensing from big movies and such for kids' meal toys. Sonic does not have that kind of budget. So it's up to us to bring something even better to the table. This is the Wacky Pack.

Phil: I used to work in the world of licensed product design. Some designers believe it would be great to work with Pokémon or one of these large properties. But any popular license comes with a huge style guide and design guidelines from which you are not allowed to stray one iota. I think that a lot of large restaurant chains think they are showing marketing smarts by riding properties that are popular but, in my opinion, they're really taking an unimaginative approach to their kids' marketing. As for any artistic opportunity, designwise, the reality is that any junior production person can follow a style guide. And, of course, then the trend is over, leaving the restaurant in a bid scramble for the next hot property.

Amy: We've worked with Sonic for about fourteen years. They had the Wacky Pack prior to our involvement, but we designed the characters they now use. By now, when people see the characters, they think of Sonic.

Phil: Among the associates in all departments, we collectively read about sixty publications a month that are either for or about kids. We watch kids' television, kids' videos, visit toy stores, hit a few comic stores every week, and play video games here in our office. We send a few associates to the annual Toy Fair and attend twenty to thirty child-related or design-related conferences a year. Also, we enjoy the benefit of having a budget to buy plenty of toy samples.

We also send somebody out to buy the kids' meals from about ten quick-service restaurants each month in order to compare products and quality. Doing all these things really helps us bring a child-friendly/child-smart focus to the Sonic project.

Dave: A lot of our research is done by going to the toy store, reading kids' magazines, or by watching television programs that kids watch. We see things that grab our attention and excite us as kids. We will often find toy ideas that inspire a completely new idea that we can create for Sonic. The challenge is to find a way to create the same type of play value in a forty-cent toy.

Amy: The people who work here are actually a bunch of big kids. Every artist and art director here collects toys that they proudly display in their office.

above: Wacky Pack Story Cards were a huge hit with parents and children alike. Using the cards, kids can create their own sentences or stories. "At Sonic, we want to help parents teach their children, and help them develop." reads a promo card that comes with many giveaways.

opposite: The restaurant chain Sonic wants to take an educational, value-based approach with its kids' meal toys, says Amy Frisch, the C3 designer who originally created the premium's four main characters, shown here. These little characters can be placed inside stories, adventures, and more.

right: Frisch and other C3 designers worked past numerous design and production hurdles to create these unique wraparound books. Once one is tied in the completely open position, it becomes a circular set of three detailed-filled stages, complete with die-cut windows and doors that allow punch-out characters to move from scene to scene. Rather than using a standard plastic bag to hold all of the pieces, one that is ripped open and thrown away, Frisch designed a resealable pouch: It functions even after the toy is opened.

Dave: With Sonic, we're designing for the three- to eight-year-old. But because a three-year-old wants to emulate older kids, we really design for the eight-year-old. The Sonic toys are meant to be somewhat aspirational.

Who's Buying?

Amy: I've also learned that even though we are trying to appeal to kids, it is the parent or grown-up who ultimately buys the product. What kids want and what parents want don't necessarily coincide. As designers, we have to find ways to appeal to both groups.

Phil: What do kids want? They do not want to be talked down to—they want to feel that they are on your level. They want their opinions heard. They want to feel loved, involved, part of whatever is going on. They want a sense of empowerment and ownership. I see toy designers forget this last point forget again and again: Their designs don't involve the child at all.

Parents want something that is fun, educational, and that shows social conscientiousness. They do not want something that just promotes the latest big craze.

"I would rather get a cheaper meal than a meal with a toy because the toys you get are dumb and they break easy." Jeremy, age 11

left: In this promotion, the Wacky Kids go on adventures around the world. Their experiences are gathered in small board books that kids can complete by adding stickers to the pages.

below: Some Wacky Pack toys are simply that—toys with no overt educational message. But every Sonic toy that C3 creates is made from high-quality materials and is well-designed. "Somebody might say, 'You're just designing a cheap kids' meal toy. Why go to all this trouble?' But kids are a lot smarter that most people think. They recognize and appreciate good design and value," says senior designer and illustrator Amy Frisch.

"The best toy ever invented is jacks. Because it has a ball." Megan, age 10

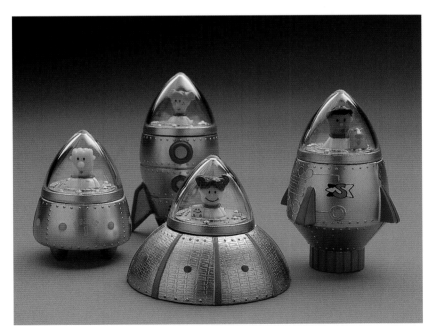

Amy: When we design a Sonic toy, we're trying to address all these things. And it's time to take the $15 idea we saw in a book or toy store and turn it into something just as fun that costs only thirty cents. The read-around books are a good example. A traditional pop-up book would just be too expensive to produce. So we designed little books that open up to form a whole world where kids can interact and identify with the Sonic characters. They can read and play at the same time.

We've also done a Halloween trick-or-treat bucket that children could design themselves with stickers. We've done a set of funny story cards: Each card has an image on it, and kids could use the cards to build their own sentences and stories.

Dave: These designs are about empowerment. They teach kids that they can do things on their own. We love to provide kids with codes, puzzles, and books; they're not too serious, but the child ends up being the person who solves the big question

Amy: Somebody might say, "You're just designing a cheap kids' meal toy. Why go to all this trouble?" But kids are a lot smarter that most people think.

They recognize and appreciate good design and value. Dumbing things down just risks losing them as consumers. With the budgets we have, we design the very best toys we can. It's personal for me; I wouldn't design something that I wouldn't want to collect myself.

Dave: Lots of times, we are just building on traditional forms. Even new trends do this: For example, Pokémon cards are really just a take-off on a more traditional form, baseball cards. We do stay up on trends, but we know what the classic successes are, too. Start with the basics, then see how they can be adapted to become relevant to a particular group of kids.

Amy: I think the Sonic premiums are successful because they are well-designed throughout. The packaging is good. The content is good. We pay attention to every element.

Dave: Of course, we think the Sonic program is great. Within two to three months after its release, we received an incredible amount of feedback, especially from teachers and parents, expressing how impressed they are with the program. Since its creation in 1998, the Sonic Wacky Pack has consistently increased Sonic Kids' meal sales.

The main thing about designing for kids is that you have to become a kid yourself. You cannot stand above kids and design from there. You have to read what they read, play with their toys, watch their movies. Then you are designing for yourself, in a sense.

above: C3 created this set of positive books for another restaurant client, Chick-Fil-A. Based on the concept behind Stephen R. Covey's *The Seven Habits of Highly Effective People,* each of the 6-inch-square books is of quality high enough to be sold in a bookstore.

left: C3 also created the Kids Creative Workshop, a school partnership program, which is designed to teach children the "three C's"—creativity, cooperation, and comparison. Teacher and student notebooks help classrooms progress through the program. Once they complete the program, students are invited to visit C3 for a tour and to learn how toys are designed.

below: C3's office space is an inspiration for kids of all ages. By creating a playful environment, managers ensure that designers stay immersed in a world kids would love.

Bubble Tape/
Amurol Confections

Amurol Confections Company was founded in 1948 by a Naperville, Illinois, dentist who invented an ammoniated toothpaste and, later, a sugar-free chewing gum. The company was purchased by the William Wrigley Jr. Company and has become purveyor of one of the most popular bubble gums ever marketed, Bubble Tape. Its engineers and designers continue to give familiar products, candy, and gum, new twists and appeals with such products as Big League Chew, Ouch! Bubble Gum, Bubble Beeper, Bug City, and Thumbsuckers. In an extremely competitive market, Amurol Confections brands remain fresh. Director of graphics, design, and new products Rocco Palowski tells how.

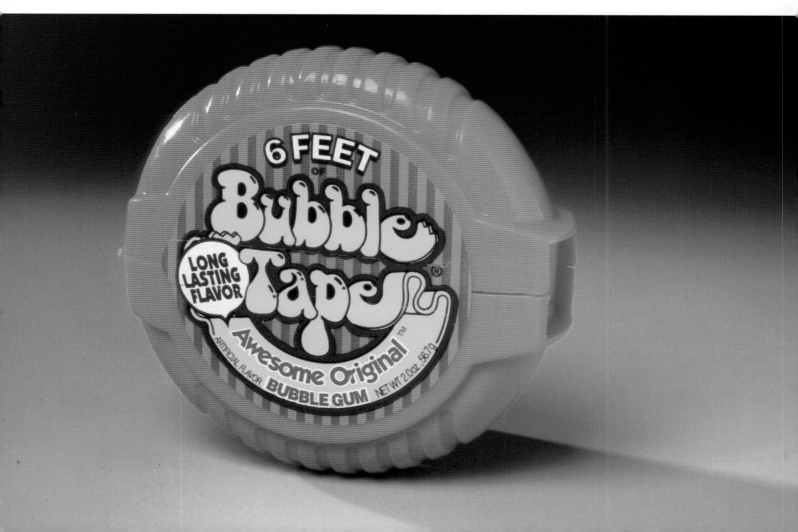

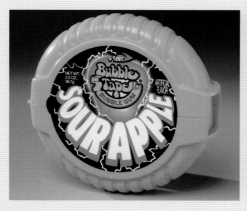

Rocco: Ideas for new products come from many sources—from employees, their kids, their friends, and others. But the system by which an idea is judged is definite. We keep an idea record. Each record has to have a product name, a detailed description, and a sketch. People in research and development and in graphics look at each idea and decide whether or not it would make a good novelty. Does it offer value? Is it fun?

Many of our product forms come out of R&D. We can now make bubble gum in this form. Designers, what can you do with it? How can you accommodate it with packaging and design? It's like being a mad scientist. To test ideas, we have a market research base of about three thousand kids who try out possible new products. A product definitely has to play well with them in order for us to proceed.

I am always getting ideas from adults who say, "This would be so cool for kids." It's usually not the case; 99 percent of these ideas won't work. For instance, many adults think that kids just love gross things. The truth is, kids are just as grossed out as adults by something like a 8-inch-long gel-candy rat. Hot movie trends don't translate well either to product or design. Kids are so inundated with media of that sort today—they are looking for something completely new.

Packaging is especially important on the retail shelf, but special packaging, like a bandage box, isn't enough. We've led the way in using fluorescent colors in packaging. Products have to scream from the shelf. We also like to show what is inside the package, if possible, on the package or on the display. Maybe we can show how to use the product or what is so fun about it.

We don't use a whole lot of words in our designs. In the retail setting, kids are especially poor—or maybe it's impatient—readers. If they can't get the idea of the product just by looking at the box, forget it. The name of the product has to be large. It just doesn't serve us well to be refined and elegant

We find that children like bright colors and lots of contrast. Often, they aren't as trendy as you might think. If you get too leading edge with a design, they might not know what the product is.

With candy products, flavors are communicated through color. Pink says bubble gum, purple is grape, red is strawberry or cherry. At the preteen or teen stage, when kids are getting interested in how attractive they are, green begins to equal mint, which equals fresh breath. After that, it gets tricky. There are lots of wild "flavors" out there now, like "cyclone." What flavor and color is that? We have done some experimentation with leaving the normal range of colors and flavors, but we must be careful because kids get confused easily, and we have their attention for only a short time in the store.

I find focus groups interesting, but children are influenced by their peers and may give a different opin-

above: Big League Chew is modeled directly after chewing tobacco, a product clearly outside the world of children. But the shredded gum inside not only tastes good, it is unique in form and it allows children to take as much or as little as they want, giving them complete control and ownership of the product.

above left: Bubble Tape revolutionized the design of bubble gum, which was previously available only in sticks or chunks. Bubble Tape offers an amazing 6 feet of gum, a promise guaranteed to excite any child's imagination. The unique design of the product is partnered with a recloseable clamshell container; young buyers can easily tuck it into their pocket or bookbag. The newest offering, Sugar-Free Bubble Tape, is sold in a container reminiscent of dental floss.

right: Ouch! Bubble gum is packaged in a familiar metal bandage box and in bandagelike strips inside. In effect, Amurol designers simply gave sticks of gum a new spin.

far right: Bubble Jug offers yet another twist on bubble gum: The jug contains gum and powdered candy, which the child shakes to mix. The little handled jug, only a few inches tall, is eye-candy all by itself, drawing plenty of attention on the retail shelf.

below: Bug City Candy definitely has the smile factor. Candy bug tarts are stored in a jar with holes in the lid. The design matches the concept, and children appreciate the humor.

ion when asked one on one, so I take focus-group findings with a grain of salt. What I do find valuable is reading their faces. If an interviewer pulls out a new product and all of them say, "Cool!" then I know we've got something

It's important to keep existing brands fresh for kids. They are always looking for something new. Bubble Tape used to come in a stock cup-and-lid container. Now it comes in a clamshell. We are also bringing out an exciting promo now in which the Bubble Tape container is brought to life. He will actually be a character in commercials, daring kids to take more. He will taunt people in a playful sort of way and say things like, "You wanna piece of me?" We just took our product and turned him into a lovable wiseguy kind of character.

What's the best design for kids? It needs to be unexpected but relevant to their lives. It can't be too far outside that box. There needs to be a measure of familiarity. Children are social; the best designs are both exciting to the individual and acceptable to the group.

In novelty confections for kids, it is key that we design products that are completely integrated. There has to be a good concept behind a product's theme that is relevant to kids' lives or to a modern trend. The product form and its packaging also has to be unique and must support the overall concept. And, as we do for any consumer, we want to deliver great-tasting product to children over and over again, plus give them a lot for their money.

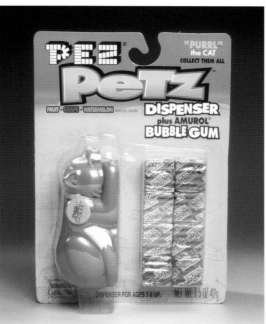

left and below: Pez speaks a familiar candy language to children. Amurol has given the old form a new spin by having the animals dispense gum. These creatures have the additional appeal of being collectible.

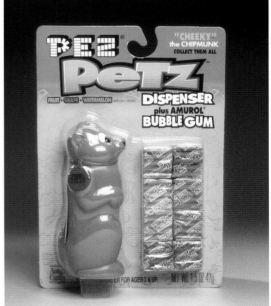

"I think gum that is shaped like tape or Band-Aids is OK for little kids, but when you get older, you don't like it as much."

Angela, age 11

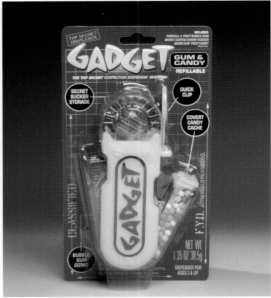

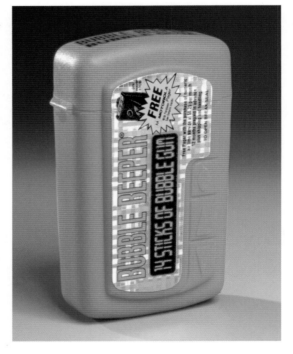

Any product we release has to have a smile factor, an element of fun or unexpected whimsy. Think of Bubble Tape: Who ever would have thought of 6 feet of bubble gum? You can just see a kid envisioning that in his mind—6 feet of gum! Ouch! is another fun product. You get sticks of gum wrapped in bandage wrappers in a bandage can. Bug City Candy definitely has the smile factor; it's a clear jar with holes in its lid filled with candy tart bugs. Someone in design came up with the idea for the bugs, then found a source for the jars and a way to put holes in the lid. The design matches the concept. Children really get that.

Another dimension that we have to be mindful of is that our products have to be acceptable to mom and dad. The days of kids riding their bikes to the corner store to buy candy is largely gone. Parents just don't let their kids go shopping on their own. So the synergy of the product, packaging, and concept has to be enjoyable to them, too. They might even buy it for themselves.

above and left: Candy or gum can be formed into different shapes, but sometimes it's the container that holds the real appeal. Cluckers is modeled after a very old toy, a wind-up chicken that lays marbles—but Cluckers lays bubble gum. Gadget is reminiscent of a multipurpose tool that mom or dad might carry, but it hides candy pellets, bubble gum, and a sucker. Bubble Beeper trades on a familiar form in some kids' lives: the beeper.

"I like the tape gum, but the kind from the tube is disgusting." Mark, age 11

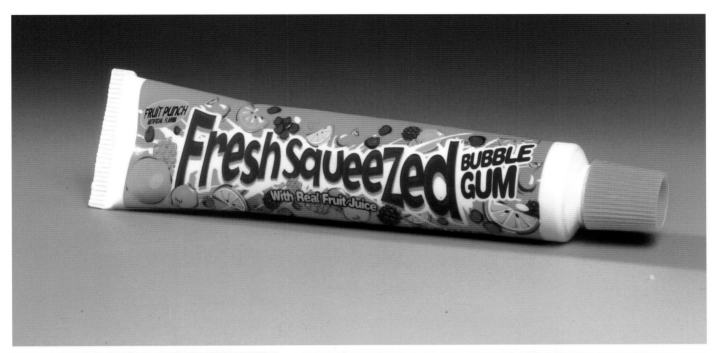

above and left: These products
are good examples of designs in
which the product and the con-
tainer are completely integrated.
Because children are always
looking for something fresh and
new, these revolutionary forms
hold a lot of appeal.

Milk Chugs

Is it possible to make milk cool? Or, with all of the juice and soft drinks available today, is milk a baby drink? Dean Foods, with the sage design advice of Wencel/Hess, turned the retail milk category on its ear when it introduced Milk Chugs®. Suddenly, milk was as portable as a Pepsi; it fit into the drink holder of a car. Children could grab a Chug® from the refrigerator, pop it open, and enjoy it all by themselves. No more asking Mom or Dad to lift and pour a heavy gallon of milk. Mike Wencel, principal of Wencel/Hess, explains how the extraordinary, but simple, concept came to be.

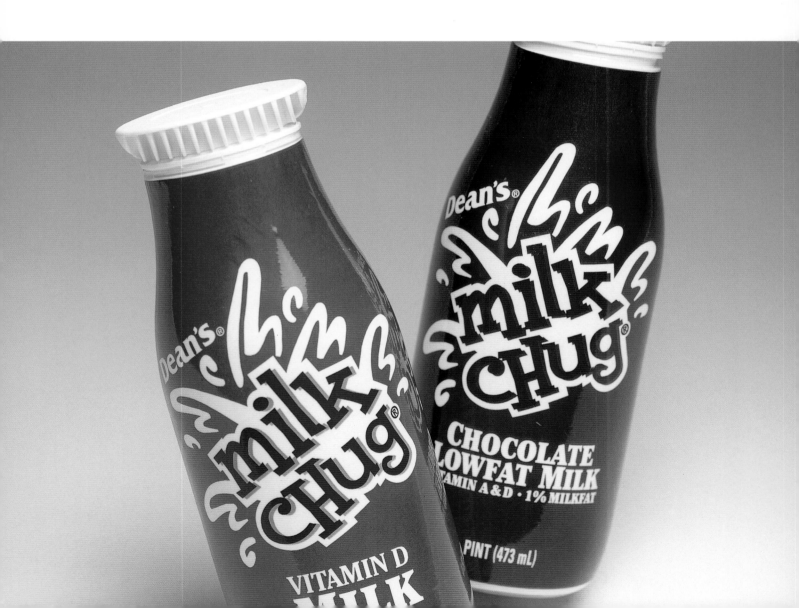

DEAN FOODS.
VITAMIN D MILK

DEAN FOODS.

VITAMIN D
MILK

QUART (946ml)

above: Like most milk packagers, Dean originally sold its products in a standard gabletop container.

opposite: Dean Foods and the design firm Wencel/Hess found a way to transform what some kids might think of as a baby drink into a cool, portable, just-for-me refresher—Milk Chugs. After the new single-serve bottles were introduced, Dean's milk sales grew 300 percent in one year. Chocolate milk sales grew 100 percent.

Mike: The fact is, when kids reach a certain age, maybe five or six, they don't want to be associated with milk anymore. If it's something their parents give them, they don't want it. It's not cool. They have to "own" something in order to really like it, and they didn't "own" milk. It was what their mom wanted or forced them to drink.

As a result, the sales of milk have been declining for years. When Dean Foods brought us into the project, its milk products were still sold in paper gabletop cartons. Dean wanted to establish the brand as the premium brand, what you would buy if you were going to get the really good stuff. From research, we knew that with milk, packaging has to say "trust" and "quality," like something your grandmother gave to your mother and your mother handed down to you.

We knew that Dean would be going into plastic screwtop packaging, so we began exploring what the next step in plastic after that would be. What with dual working families and everyone being on the go all the time, single-serve bottles seemed to be the next step. Consumers or children will not grab a gallon of milk at the convenience store: They will, however, grab a single-serve.

We had seen some other pint bottles on the market that looked pretty medicinal. They had wraparound labels that just contained nutritional information. For branding, they were pretty weak.

A New Direction

We decided to go totally proprietary with the design of our packaging. We explored unique caps and bottles and decided on a shrink wrap that would entirely cover and brand the bottle. What we ended up with actually looked a lot like an old-fashioned milk bottle, which was appropriate for tradition and parents. But wait a minute—we were trying to attract young kids. Would this work? Marketers call this age group "the young cannibals." They know what they want. They are supercharged. They have to own what they like.

That is where the name and the graphics in the bottle come into play. Chug is sort of a kid word—it's not something a grown-up would say in connection with milk. It's also short, so it's a good word to position on a tall and narrow container. Consumers read from the top of a package down, so you need something striking at the top of the container.

The graphics are really funky and contemporary. Larger containers have the splashing glass of milk; smaller containers just have the splash. The national identifier is the splash. It works well, particularly for non-English-reading consumers: They see the mark and know right away what it is.

But even though it's different from other milk packaging, the design clearly indicates that this is milk. You can't go off and try to make this out to be a new Pepsi or Coke, or kids will be mad when they try it. It's milk. It's the real deal. You've only got four to six seconds to grab consumers as they scan a store shelf. But if you can get them to pick it up, 90 percent of the time they will buy it. So making the brand and product message clear quickly is crucial.

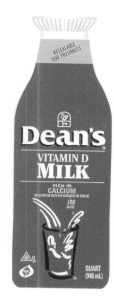

right: A redesign for the gabletop would refresh the brand's presence, but it wouldn't revitalize sales, which had been slumping for years.

far right: Experience told designers at Wencel/Hess that the single-serve bottle was a trend in the beverage industry, but most other producers used a wraparound label that had little impact.

below right: A shrink-wrapped label that covered the entire bottle was unique for the category, and its large surface area provided plenty of space for color and graphics.

SELL BY TO OPEN ▶

Color Messaging

Our bright colors send a message of quality and freshness, but you have to be very careful about color coding in this category. Dairy consumers, even kids, are conditioned to what colors milk should be. Red containers always indicate vitamin D. Two percent milk is dark blue; 1 percent and lesser percentages of fat are lighter blue. Regular chocolate milk is dark brown and reduced-fat chocolate milk is light brown. That's it. If you mess with that coding and the consumer gets home with whole milk when he wanted 2 percent, he will not be happy. That's where some dairies are getting into trouble trying to appeal to kids with four-color graphics and other busy art; this type of packaging does not communicate that this is milk.

After Milk Chugs were introduced, Dean's milk sales grew 300 percent in one year. Chocolate milk sales alone grew 100 percent. The 1 percent chocolate has become popular with women, and we even see construction workers buying quart bottles and downing them at work.

It's the reverse of the regular situation, where adults influence children. Kids are influencing the adults to try Chugs. The best-built brands are the word-of-mouth brands. Kids discover this brand, think it is

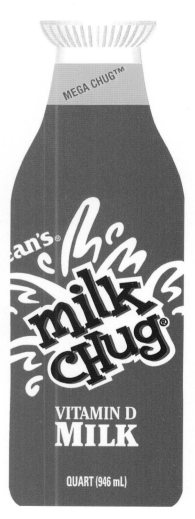

left: The splash logo, together with the Chug's old-fashioned milk bottle look, helps buyers who don't read English understand what is inside the bottle.

below left: Dean does not try to trick young buyers into thinking that Chugs are a new kind of soft drink; it's milk, pure and simple. But the company does portray the product in the same cold, refreshing, action-packed settings that soft drinks often use. This is milk for people on the move.

cool, and feel they are in the know, so they pass it on. They want everyone to know that they are the cool person in the group. Do they care that it is good for them? I doubt it. They want to feel independent from statements like "It will make you big and strong."

Milk Chugs work because they are different and therefore cool. We respects kids by giving them a high-quality product in a package made especially for them. If you can give a product perceived value through graphics or design as well as provide a good product, then tie those two elements together into something kids can own, you've got communication.

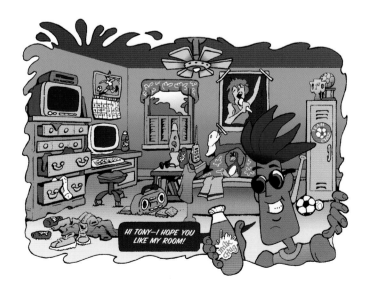

left: Chaz, an athletic, cool older teen, was created to be Milk Chug's host and mascot character. On Dean's Web site, children can roam through Chaz's messy room and play games.

right: Chaz is also used in retail and marketing campaigns. In a store, the snappy-looking packaging, shown together with Chaz, is a sure attention getter.

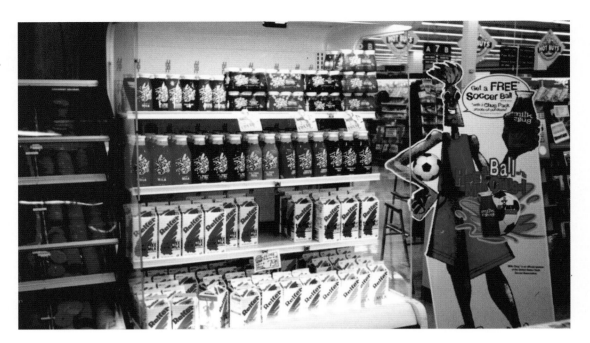

"The dumbest TV commercial is the Nesquick one where the kid hits a home run into outer space and an alien catches it. Everyone knows there is no such thing as aliens."

Scott, age 6

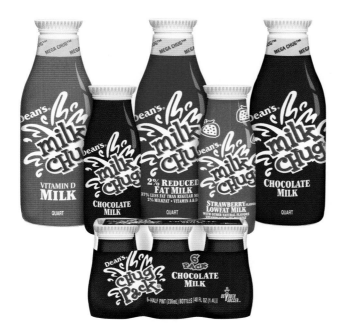

"If someone invented bubble-gum flavored milk, I would get a small bottle and try it." Adam, age 12

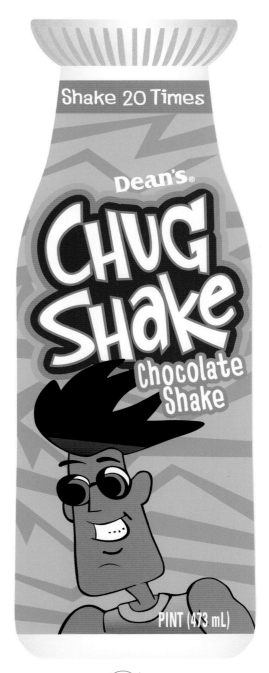

Shake 20 Times

Dean's®

Chug Shake
Chocolate Shake

PINT (473 mL)

above: Chugs respects color conditioning that is unique to the milk industry. While other milk packagers use wild colors to grab the eye of a child, they only confuse the buyer. For guaranteed success, vitamin D milk must be packaged in red, 2 percent in dark blue, 1 percent and lower fat percentages in lighter blues, and chocolate milk in brown. Strawberry-flavored milk, a more recent innovation, is in pink, naturally.

right: The Chugs concept has proven so popular that Dean Foods is exploring new beverages, like the Chug Shake.

"You learn things from drinking soda. Kids should drink soda so they know how much to drink." Josie, age 9

10-12

AGE CUES, DESIGN CLUES

year olds

Age Cues—Design Clues for 10 to 12 year olds

Many children in this group are becoming physically mature; others remain planted squarely in childhood. But whatever their height, 10- and 12-year-olds still love to play, although they think of themselves as very mature. They long to feel included as a necessary and useful member of a larger group. They also are beginning to challenge adults with their own ideas. Extreme emotions are emerging. Designs for this group can build on these feelings: Strong graphics, high color levels, sharp contrasts have appeal. Junior versions of grown-up looks, however, still feel more appropriate to their caregivers.

MOTOR AND PHYSICAL DEVELOPMENT
Enjoy team sports. • Like graphics that imply team affiliation, even if user/wearer does not play that sport.
Excellent eye-hand coordination. • Can work on detailed crafts. • Can appreciate detailed graphics and animations. • Skilled at computer and video games—anything with buttons.
Require even more rest due to increase activity levels. Can feel stressed. • Designs that allow quiet time or downtime. • Cool or calm colors have a pronounced effect.
Body changes may result in self-consciousness. • Activities that allow children to hear others voice their self-consciousness are effective. • Designs that help children form a positive self-image are beneficial.

SOCIAL SKILLS
Growing importance of friendships. • Like graphics that identify them as a member of a larger group. • May pay less attention to collections or hobbies (inward activities). • Graphics that involve a symbolic or coded language that only this age group appreciates are welcome.
May take on causes that they feel deeply about. May take on the problems of others. • Graphics can reflect popular causes: nature, fairness, brotherhood, and so on. • Graphics can relate in more abstract ways to causes. Example: brown and greens reflect an interest in nature.
May challenge beliefs they did not question before. • Colors, textures, and patterns that are daring or experimental may become more intriguing.
May become more emotional. • Higher pitches of color and contrast are a natural reflection of mood. • Typefaces that have their own mood work well.

INTELLECTUAL AND COGNITIVE DEVELOPMENT
Can work on longer and more complex projects. • More complex graphics are appropriate. • Designs that help children organize or compartmentalize are helpful.
Learning more about the world, including myths and biographies. • Designs can include more and varied cultural references. Interested in learning how things work. • Use graphics that explain assembly, construction, or mechanical methods.
Continued development of math skills. Introduced to geometry. • Designs can have more sophisticated rhythms. • Designs can include more spatial interpretation. • Use geometric shapes in designs.
Can think ahead several steps. • Strategy games, puzzles, and long-term projects are more feasible. • Activities that include brainteasers are popular.
Can debate and see several sides to a single issue. • Reasoning skills and personal opinions allow child to personalize, reorganize, or customize designs effectively. • Activities that include reading or writing about personal opinions are popular. • Designs can include what-if scenarios.
Able to read newspapers and magazines • Designs can rely on knowledge of current events or recent history. • Read about specific interests, like sports or finances.

Directory

Amurol Confections Company
Rocco Palowski, Director of Graphics
2800 North Route 47
Yorkville, IL 60187
(630) 553-4647
(630) 553-5322 fax

Barbie
Parham Santana
Maruchi Santana, Principal
John Parham, Principal
7 West 18th Street
New York, NY 10011
(212) 645-7501
(212) 645-8314 fax

BRIO Corporation
Peter F. Reynolds, President
N120 W18485 Freistadt Road
Germantown, WI 53022
(262) 250-3240
(262) 250-3255 fax
www.briotoy.com

Candlewick Press
Chris Paul, Art Director
Ann Stott, Associate Art Director
2067 Massachusetts Avenue
Cambridge, MA 02140
(617) 661-3330
(617) 661-0565 fax
www.candlewickpress.com

Cheerios
General Mills
Beth Rampelberg,
Senior Design Coordinator
Liv Lane, Cheerios Spokesperson
1 General Mills Boulevard
Minneapolis, MN 55426
(763) 764-4830
(763) 764-3232 fax
www.generalmills.com

Children's Museums
Carolyn Crowley, Designer
Lee H. Skolnick Architecture + Design
Partnership
7 West 22nd Street
New York, NY 10010
(212) 989-2624
(212) 727-1702 fax
www.skolnick.com

Children's Museum of Manhattan
212 West 83rd Street
New York, NY 10024
(212) 721-1223
(212) 721-1127 fax

Crazy Bones
Timothy M. Shea
Toy Craze
26401 Fargo Avenue
Cleveland, OH 44146
(216) 595-0807
(216) 595-7229 fax
www.toycraze.com

Design Explorers
Beth Singer
Beth Singer Design
1910 1/2 17th Street NW
Washington, D.C. 20009
(202) 483-3967
(202) 332-7107 fax

Sam G. Shelton
KINETIK
1436 U Street NW
Suite 404
Washington, D.C. 20009
(202) 797-0605
(202) 387-2848 fax

Bill Gardner
Chris Parks
Gardner Design
3204 East Douglas
Wichita, KS 67208
(316) 691-8808
(316) 691-8818 fax
www.gardnerdesign.com

Get Real Girl
Julz Chavez, Creator
2565 Third Avenue
Suite 322
San Francisco, CA 94107
(415) 821-0234
(415) 377-5444 fax
www.getrealgirl.com

Kids Discover
Hopkins/Baumann
236 West 26th Street
New York, NY 10011
(212) 727-2929
(212) 727-3776 fax
hq@hopkinsbaumann.com

Kids' Studio
Alla Kazovsky
8342 West 4th Street
Los Angeles, CA 90048
(323) 655-4028
(323) 655-4178 fax
kidsstudio@juno.com

Klutz
MaryEllen Podgorski, Art Director
455 Portage Avenue
Palo Alto, CA 94306
(650) 857-0888
(650) 857-9110 fax
www.klutz.com

Milk Chugs
Lee Ann Benedict
Dean Foods Company
10255 West Higgins
Suite 500
Rosemont, IL 60018
(847) 375-6537
(847) 375-6599 fax
www.deanfoods.com

Michael Wencel Sr.
Wencel/Hess
733 North LaSalle
Chicago, IL 60610
(312) 255-1511
(312) 255-1611 fax

Nickelodeon magazine
Tina Strasberg, Art Director
1515 Broadway, 37th Floor
New York, NY 10036
(212) 258-7395
(212) 846-1752 fax
www.nickelodeon.com

Noggin
Kenny Miller, Vice President for
Programming
1633 Broadway
New York, NY 10019
(212) 654-6638
(212) 654-4879 fax
www.noggin.com

Ringling Bros. Circus
Big Blue Dot
Robert Troutman, Design Director
Scott Nash, Creative Director
63 Pleasant Street
Watertown, MA 02472
(617) 923-2583
(617) 923-8014 fax
www.bigbluedot.com

San Diego Zoo and Wild Animal Park
Karen Worley, Editor
Inigo Figuracion, Web Site Manager
Zoological Society of San Diego
P.O. Box 120551
San Diego, CA 92112-0551
(619) 231-1515
(619) 557-3970 fax
www.sandiegozoo.com

Sonic Toys
C3
Phil Reynolds, Creative Director
Dave Swearingen, Art Director
Amy Frisch, Senior Designer/Illustrator
10955 Granada Lane
Overland Park, KS 66211
(913) 491-6444
(913) 491-4688 fax
www.c3.to

Teacher's Pet
Gary Baseman, Executive Producer
Disney Corp.
500 South Buena Vista Street
Burbank, CA 91521
(818) 560-1000
(818) 566-6566 fax
www.disney.com/teacherspet

WillingToTry.com
Funny Garbage
John Carlin, Founder
73 Spring Street
Suite 406
New York, NY 10012
(212) 343-2534
(212) 343-3645 fax
info@funnygarbage.com

Zillions
Robert C. Jenter, Art Director
Charlotte Baecher, Editor
101 Truman Avenue
Yonkers, NY 10703
(914) 378-2542
(914) 378-2985 fax
www.zillions.com

About the Author

Catharine Fishel runs Catharine & Sons, a full-service editorial company that specializes in working with designers and related industries. She frequently writes for *Step-by-Step Graphics, PRINT, U&lc, I.D.,* and other trade publications. She is the author of *Paper Graphics, Minimal Graphics, Redesigning Identity,* and *The Perfect Package* (all by Rockport Publishers).